CRAFT COCKTAILS

Endpages: Newspapers: © The Granger Collection, New York;
Upper left corner: © Corbis; *Police Magazine*: © Collection Kharbine-Tapabor.

© 2013 Assouline Publishing
601 West 26th Street, 18th floor
New York, NY 10001, USA
Tel.: 212 989-6769 Fax: 212 647-0005
www.assouline.com
ISBN: 9781614281030
Photo retouching by Luc Alexis Chasleries.
Art direction by Camille Dubois.
Printed in China.
The photographs of the cocktails featured in this book were shot at Death & Co., PDT
(Please Don't Tell), Clover Club, and Employees Only in New York.

BRIAN VAN FLANDERN

CRAFT COCKTAILS

PHOTOGRAPHY BY HARALD GOTTSCHALK

FOREWORD BY FRANCESCO LAFRANCONI

ASSOULINE

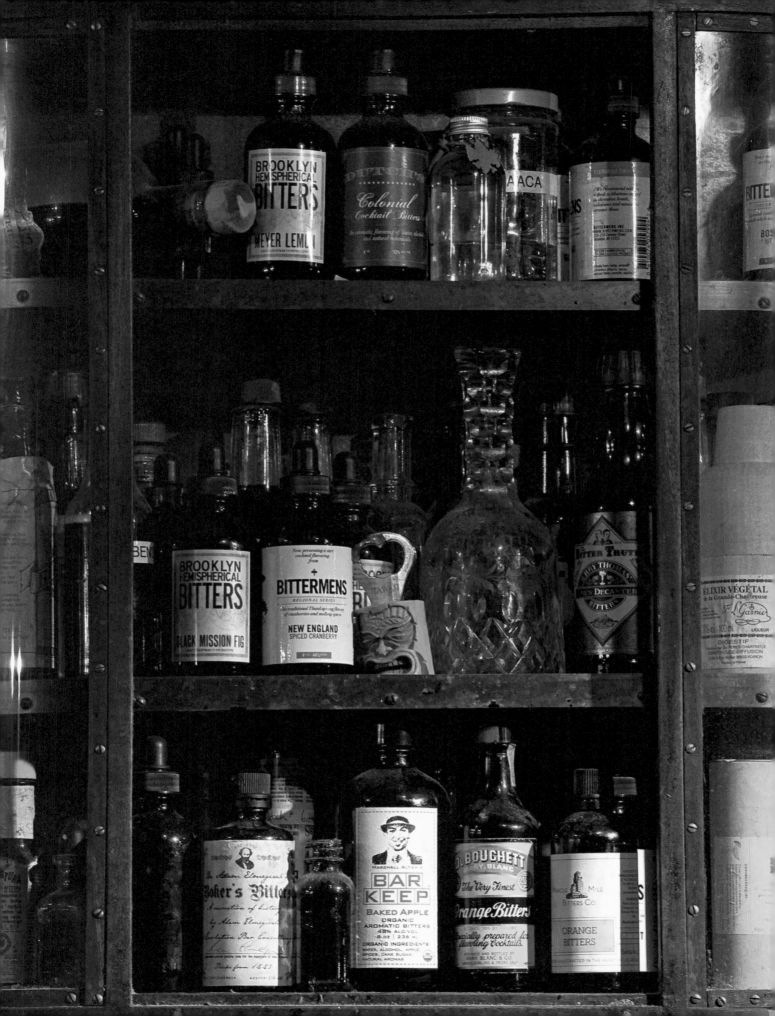

FOREWORD

by Francesco Lafranconi

I first met Brian Van Flandern when Chef Thomas Keller invited me to host a spirits-mixology seminar for the opening crew at Per Se in 2004. After the seminar, Brian took me around the city to experience some great craft cocktail lounges that were just beginning to become popular. What struck me most was his ability to retain all information about anything inherent to cocktails and spirits.

Brian's craft cocktails are the embodiment of integrity through service, style, technique, and uncompromised quality—using only fresh ingredients and the finest spirits and liqueurs available on the market. His creativity when pairing flavors encourages you to approach cocktails as a culinary art form and truly inspires your best efforts. Not only was Brian responsible for the global "tonic fever" that emerged in 2004, but he was also the first to promote house-made tonic water using quinine powder and was among those responsible for relaunching cognac and sherry as key ingredients in cocktails.

I hope you enjoy this collection of crafty yet accessible recipes as much as I do. There is something for everyone in this book. These amazing cocktails are presented in the finest glassware and enhanced by stunning photography, where every image captures the essence and soul of each drink and seems to bring them to life.

Salute!

Francesco Lafranconi
Executive Director of Mixology & Spirits Education
Southern Wine and Spirits

INTRODUCTION

Prohibition killed the cocktail. . . . for awhile, at least. From 1920 to 1933 the temperance movement made it illegal to manufacture or sell alcohol, forcing the best bartenders to flee the United States and ply their trade in Europe.

Following World War II, the silver screen popularized Martinis, Stingers, and Manhattans, but the execution of these classics was often poor. By the 1950s and 1960s emerging enfant palates became used to imbibing drinks high in alcohol. Sweet liqueurs were in vogue in the 1970s and 1980s, with Sex on the Beach, White Russians, and Mudslides regularly showing up on menus. Finally, in the late 1990s, the cocktail's fate began to improve.

Today we are the midst of a cocktail revolution. Whereas fixing a good drink once required little more than a decent bottle of alcohol, some mixers, and a shaker, mixologists have rediscovered the culinary art of craft cocktails. Sourcing local, fresh ingredients; balancing acids and sugars; and devising original flavor profiles that are pleasing to both the palate and the eye all define the craft cocktail.

While this recently embraced movement sounds avant-garde, the art of the craft cocktail is hardly new. Returning to pre-Prohibition values by making their own tonics, tinctures, syrups, and infusions, mixologists are also immersing themselves in spirits education, studying spirit categories and their individual labels, *terroirs,* distillation techniques, and denominations of origin. They are additionally reviving the recipes of the original father of mixology, Professor Jerry Thomas (1830–1885), with a whole new range of fresh ingredients and quality spirits. In effect, the craft cocktail movement has changed the way drinks are created.

In 2004, I was hired at a new restaurant in New York City called Per Se, owned by Michelin-Three-Star chef Thomas Keller. The wine director, Paul Roberts, taught me how to pair wines with food, while Chef Keller encouraged me to experiment with the cocktail program. My goal was to create cocktails honoring the incredible dishes coming out of the kitchen and I began applying the same principles of flavor profiling for matching wine and food to my drinks. I was shocked when Frank Bruni, then *The New York Times* food critic, mentioned

my house-made Tonic with Gin in his four-star review of the restaurant. As I received more praise for my work, I began to recognize that my bartending job had morphed into a rewarding career for which I had developed a passion.

During this time mixologists Julie Reiner and Audrey Saunders opened Pegu Club in New York with a motley crew of bartenders, all of whom have gone on to have successful careers at some of the most frequented bars in the city. The clever recipes produced at these addresses sparked a flurry of press that spread like wild fire. Now every major city (and many minor ones) boasts at least one or more craft cocktail lounge.

After the extraordinary success of our award-winning first book, *Vintage Cocktails,* I wanted to write a companion showcasing not only my craft cocktail recipes, but also the unique drinks created at four of New York City's top craft cocktail lounges: Death & Co., PDT (Please Don't Tell), Employees Only, and Clover Club in Brooklyn. With so many venues popping up, these four stand out for their innovative drinks, retro-chic ambiance, and high standards of service.

Included in this book are cocktails that I developed for Per Se, *The World* ship, Bemelmans Bar at The Carlyle hotel, and Tiffany & Co., among others. All of the recipes are tried, true, tasty, and fun. Because I approached these drinks as a culinary art form, they are a bit more labor intensive than your standard classics. Unlike most cocktail books, I listed the names of specific brands for each recipe and focused on details regarding everything from the garnish to the color of a drink. Each spirit was specially selected for its unique properties and flavor profile or provenance.

I encourage you to work your way through this book and to not be intimidated by spirits that you aren't familiar with. Of course you may use substitutions if you can't find a particular spirit, but you should never compromise on fresh ingredients. I invite you to celebrate the golden age of the craft cocktail and embrace a whole new world of flavors.

Drink responsibly and enjoy. Until our next cocktail together . . . Bottoms up!

Brian Van Flandern

Founder of Creative Cocktail Consultants & Mixologist

CONTENTS

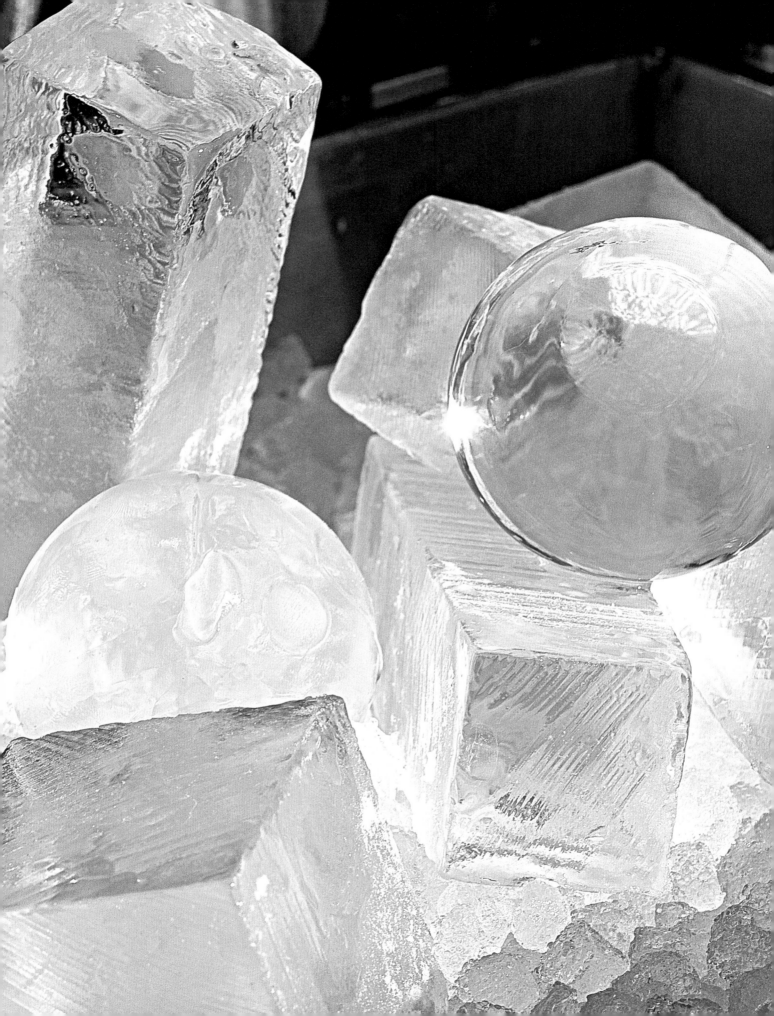

KROPLA LEMON

BASE SPIRIT: Vodka // MODIFIERS: Citrus Vodka & Moscato d'Asti

3/4 oz. FRESH LEMON JUICE

1 oz. CANE-SUGAR SIMPLE SYRUP

1 1/4 oz. BELVEDERE VODKA

1 1/4 oz. BELVEDERE CITRUS VODKA

3/4 oz. SARRACO MOSCATO D'ASTI

1 tsp. SUGAR IN THE RAW

GARNISH: RIM DISH WITH LEMON JUICE, THEN LIGHTLY DIP IN CONFECTIONERS' SUGAR; GARNISH WITH LEMON PEEL.

PLACE ALL INGREDIENTS EXCEPT MOSCATO D'ASTI AND SUGAR IN THE RAW IN A MIXING GLASS. ADD LARGE ICE CUBES AND SHAKE VIGOROUSLY. ADD MOSCATO D'ASTI. TUMBLE ROLL BACK AND FORTH ONCE. TASTE FOR BALANCE. RIM DISH, THEN DOUBLE-STRAIN. ADD SUGAR; LET IT SETTLE ON THE BOTTOM. GARNISH AND SERVE.

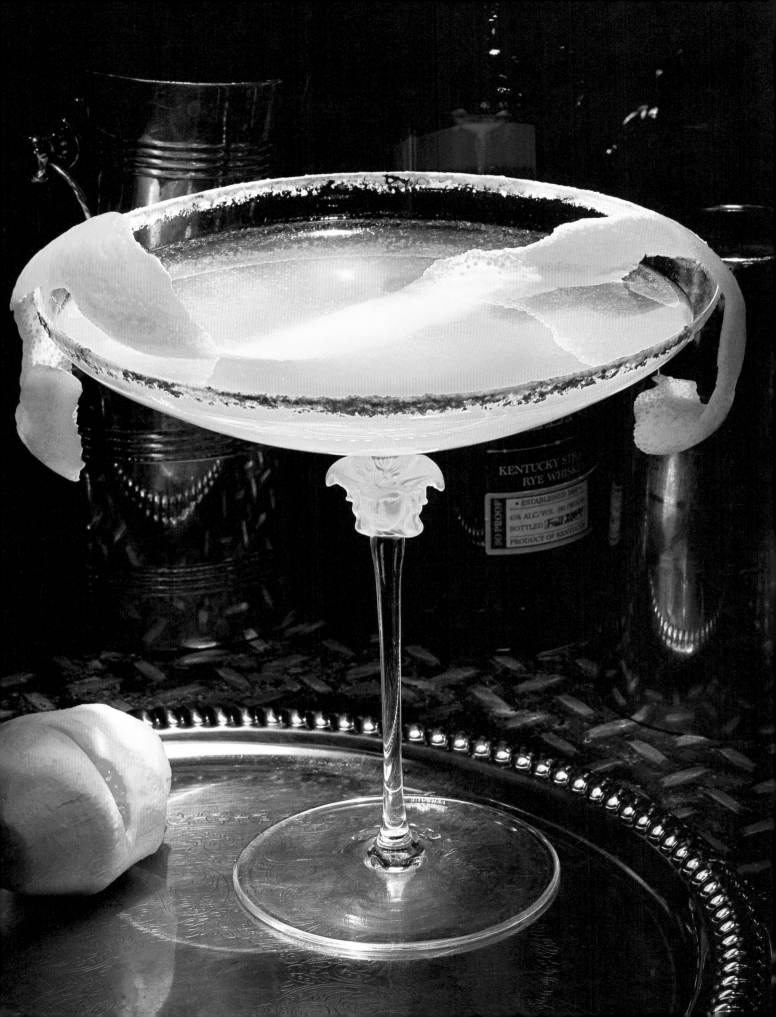

PORT OF CALL

BASE SPIRIT: Gin // MODIFIER: Ruby Port

1 DASH JERRY THOMAS' OWN
DECANTER BITTERS

1 tsp. CRANBERRY RELISH

1/2 oz. FRESHLY GROUND
CINNAMON BARK

3/4 oz. FRESH LEMON JUICE

1 oz. SANDEMAN RUBY PORT

1 oz. FORD'S GIN

GARNISH: FRESH BERRIES & MINT LEAVES

PLACE ALL INGREDIENTS IN A MIXING GLASS.
ADD LARGE ICE CUBES AND SHAKE VIGOROUSLY.
TASTE FOR BALANCE. DOUBLE-STRAIN INTO A GLASS
OVER CRUSHED ICE, GARNISH, AND SERVE.

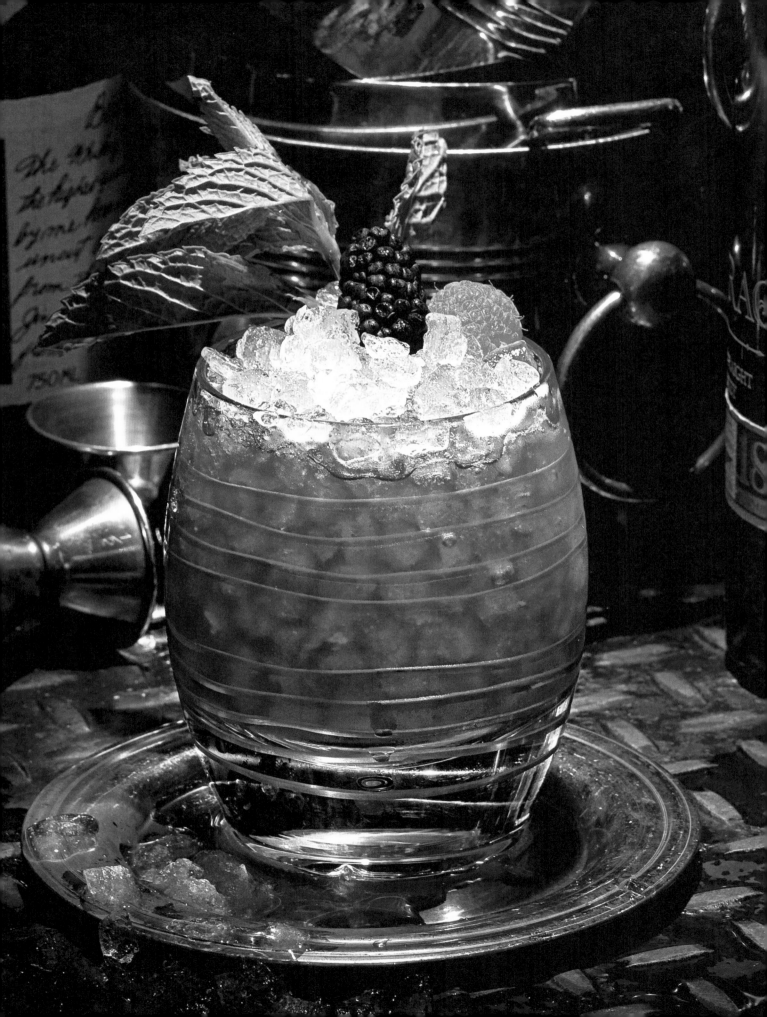

THE STANDARD

BASE SPIRIT: Gin // MODIFIER: Yellow Chartreuse

4 DASHES REGAN'S ORANGE
BITTERS No.6

1 oz. FRESH RUBY RED
GRAPEFRUIT JUICE

3/4 oz. FRESH LEMON JUICE

3/4 oz. YELLOW CHARTREUSE

1 1/2 oz. BOMBAY SAPPHIRE GIN

PLACE ALL INGREDIENTS IN A MIXING TIN.
ADD LARGE ICE CUBES AND SHAKE VIGOROUSLY.
TASTE FOR BALANCE. DOUBLE-STRAIN,

GARNISH:
GRAPEFRUIT TWIST

GARNISH, AND SERVE.

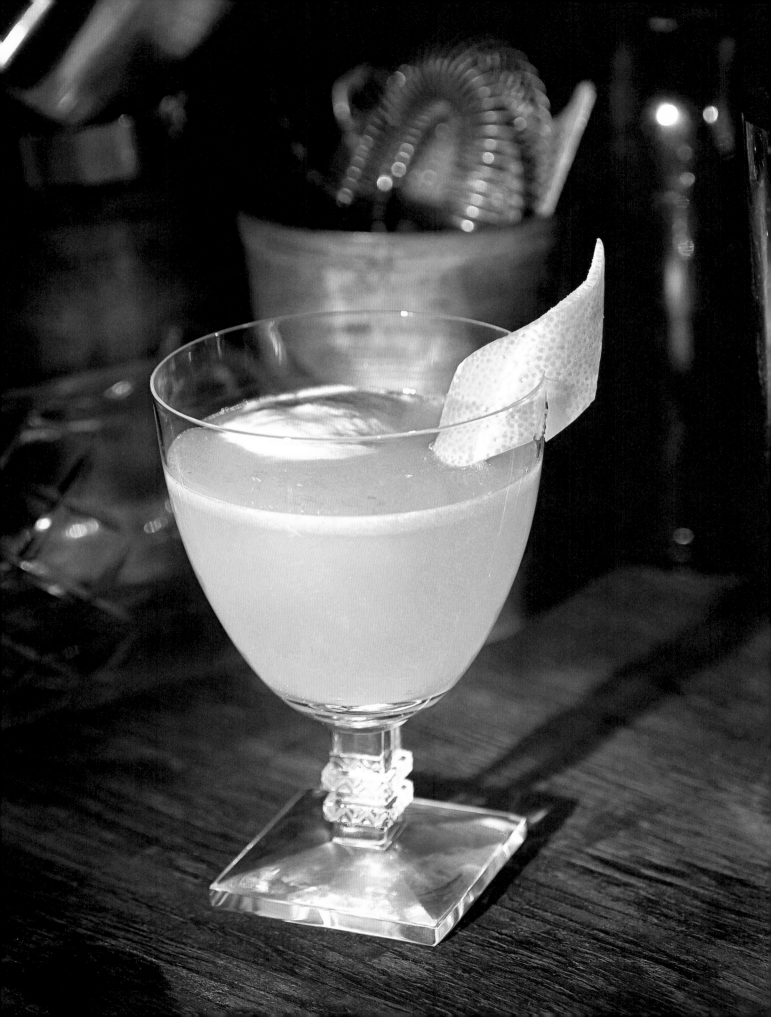

RUM & SMOKE

BASE SPIRITS: Light Rum & Aged Rum // MODIFIERS: Scotch & Mezcal

1 oz. FRESH LIME JUICE

1 1/4 oz. CANE-SUGAR SIMPLE SYRUP

1/8 oz. DEL MAGUEY TOBALA MEZCAL

1/8 oz LAGAVULIN 16-YEAR SINGLE-MALT SCOTCH

1/2 oz. EL DORADO 15-YEAR SPECIAL
RESERVE AGED RUM

1 oz. BANKS LIGHT RUM

1/4 oz. GINGER BEER

GARNISH: HALF-RIM WITH LIQUID SMOKE AND CRUSHED TOBACCO (FOR AROMATICS)

GARNISH A HIGHBALL GLASS.
PLACE ALL INGREDIENTS EXCEPT GINGER BEER
IN A MIXING TIN. ADD LARGE ICE CUBES AND SHAKE VIGOROUSLY.
ADD GINGER BEER AND TUMBLE ROLL BACK AND FORTH 1 TIME.
TASTE FOR BALANCE. ADD FRESH ICE TO GLASS,
DOUBLE-STRAIN INTO IT, AND SERVE.

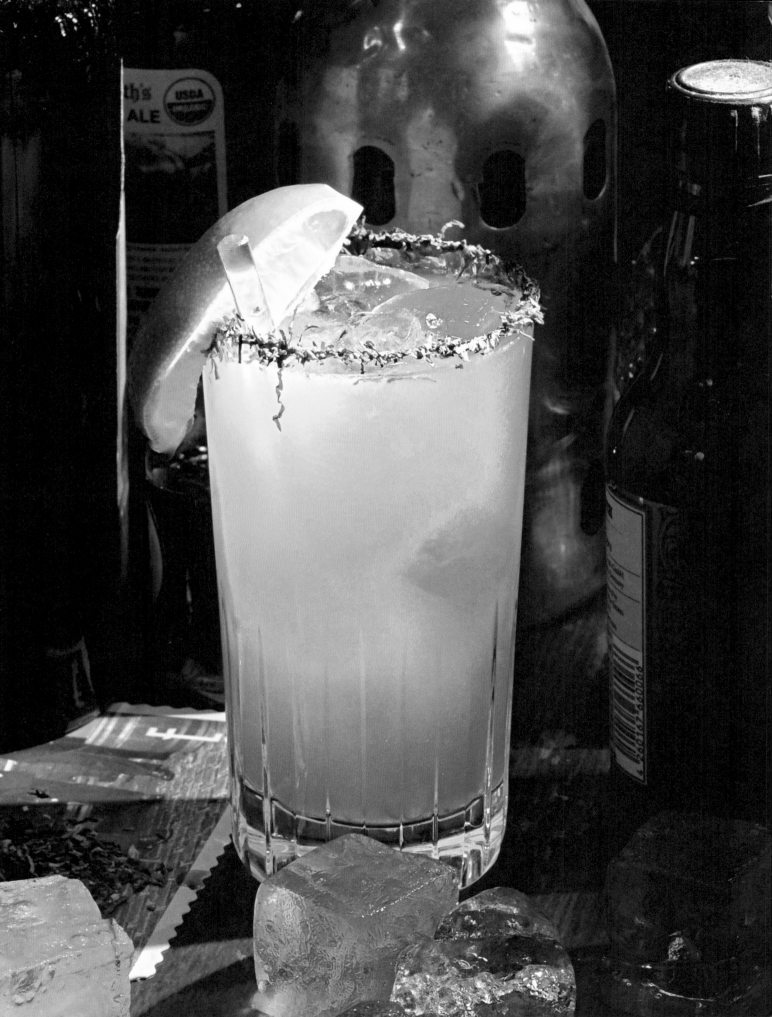

HOT BUTTERED CHESTNUT RUM

"CHRISTMAS IN A CUP"

BASE SPIRIT: Aged Rum

1 HEAPING tbsp.

CHESTNUT BUTTERED PASTE (SEE BELOW)

2 oz. STEAMED HALF-AND-HALF

½ oz. ZACAPA CENTENARIO 23-YEAR

SOLERA RUM

GARNISH:
DUST FRESHLY
GROUND NUTMEG
OVER STEAMED HALF-
AND-HALF FOAM.

ADD TEMPERED PASTE TO **HALF-AND-HALF**. STEAM **HOT** HALF-AND HALF AND PASTE UNTIL MELTED, THEN POUR INTO CUP. STIR IN RUM WITH A DEMITASSE SPOON. TASTE FOR BALANCE. GARNISH WITH FOAM AND NUTMEG, AND SERVE.

CHESTNUT BUTTERED RUM PASTE (ENOUGH FOR 20 DRINKS): 1 lb. salted butter, ¼ cup chestnut paste (or ¼ cup almond paste), 1½ cups brown sugar, 4 tsp. fresh cinnamon, 1 tsp. allspice, 2 tsp. confectionary vanilla-bean extract (nonalcoholic). Mix all ingredients together to make a paste and refrigerate. Temper paste to room temperature before using.

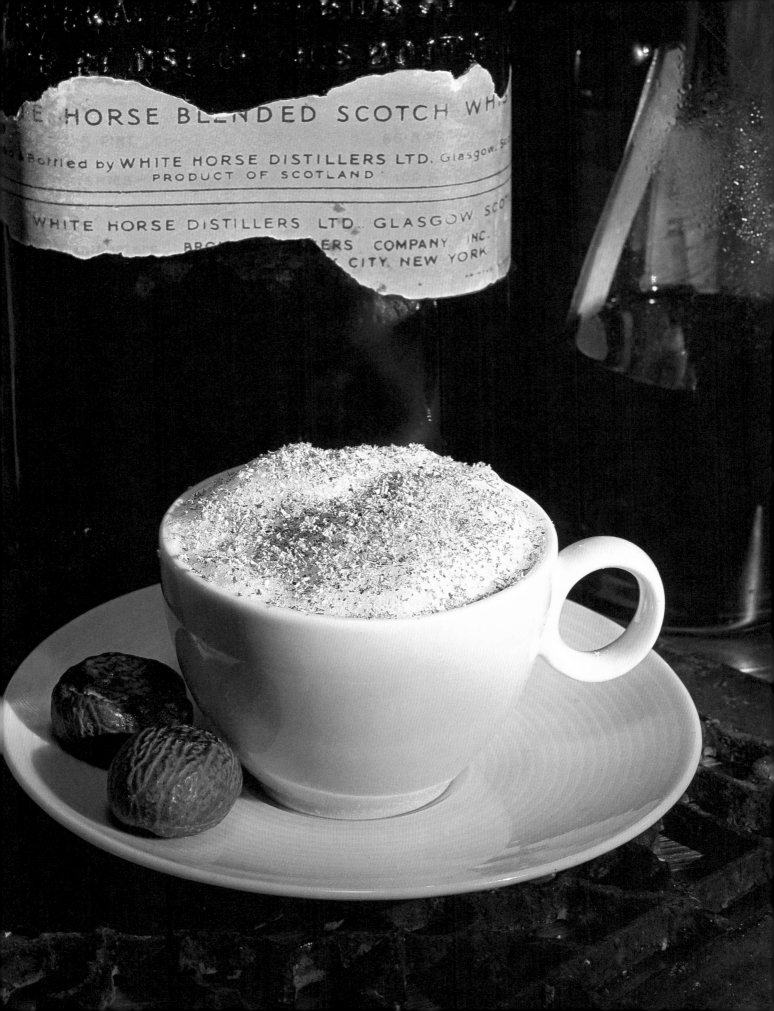

CAPTAIN'S CHOICE

BASE SPIRIT: Rum // MODIFIER: Aquavit

3/4 OZ. FRESH LIME JUICE

1 OZ. CANE-SUGAR SIMPLE SYRUP

1 EGG WHITE

1/4 OZ. SIMERS OSLO AQUAVIT

1 OZ. BANKS RUM

2 DASHES ANGOSTURA BITTERS

GARNISH: LIME PEEL

PLACE ALL INGREDIENTS IN A MIXING TIN, DRY-SHAKE
WITH HAWTHORNE COIL STRAINER, ADD LARGE ICE CUBES
AND SHAKE VIGOROUSLY. TASTE FOR BALANCE.
STRAIN INTO A GLASS, GARNISH, AND SERVE.

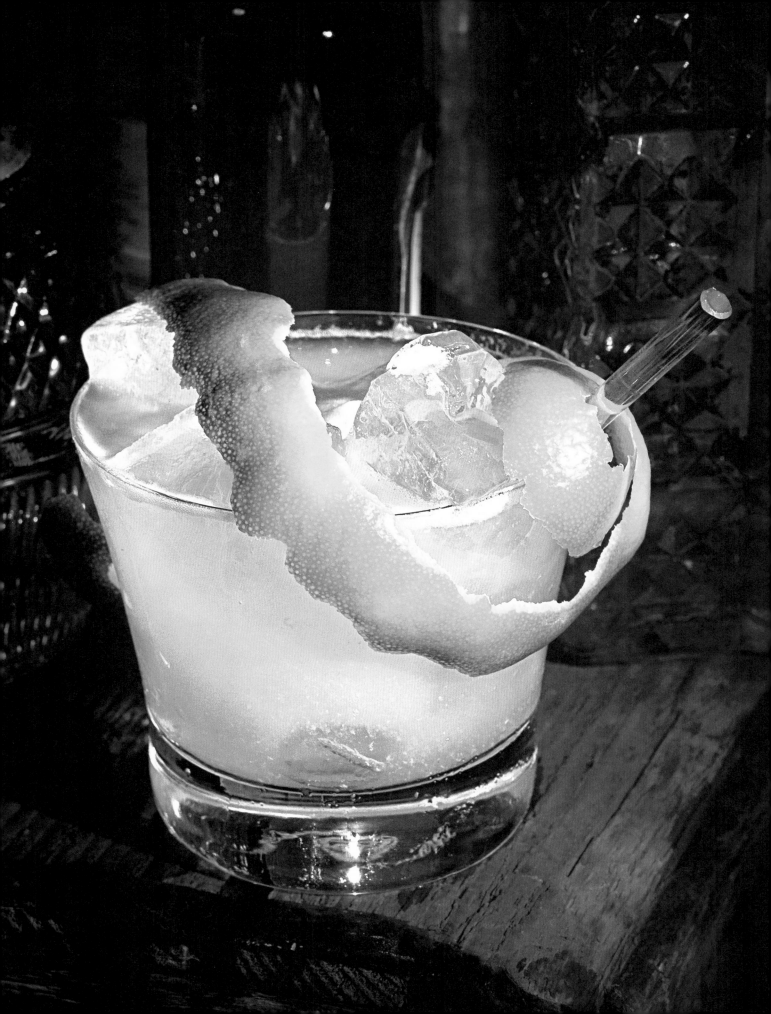

BY ANY OTHER NAME

BASE SPIRIT: Gin // MODIFIERS: Genever & Crème de Violette

CRÈME DE VIOLETTE RINSE

1/4 oz. BOLS GENEVER

1 1/2 oz. PINEAU DES CHARENTES

2 1/4 oz. HENDRICK'S GIN

1 DROP ROSE WATER

GARNISH: ROSE PETAL & LEMON TWIST

RINSE OUT A COUPE WITH CRÈME DE VIOLETTE. PLACE ALL INGREDIENTS IN A MIXING GLASS. ADD LARGE ICE CUBES AND STIR THOROUGHLY. TASTE FOR BALANCE. SINGLE-STRAIN INTO GLASS, GARNISH, AND SERVE.

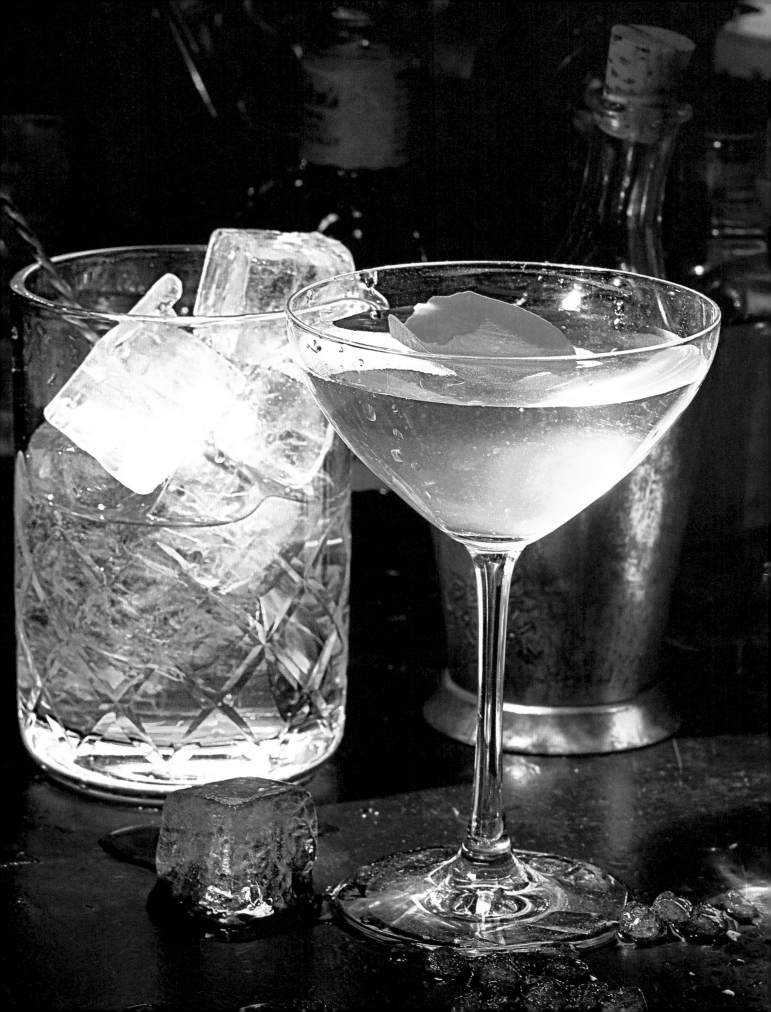

LION'S TOOTH

BASE SPIRIT: Gin // MODIFIERS: Dandelion Cointreau & Green Chartreuse

GARNISH:
YELLOW
DANDELION
FLOWER
(IF IN SEASON)

1/4 OZ. FRESH LIME JUICE
1/2 OZ. CANE-SUGAR SIMPLE SYRUP
1 1/2 OZ. DANDELION-GREEN JUICE (SEE BELOW)
1/4 OZ. DANDELION-INFUSED COINTREAU (SEE BELOW)
1/2 OZ. GREEN CHARTREUSE
1 OZ. G'VINE GIN

PLACE ALL INGREDIENTS IN A MIXING GLASS. ADD LARGE ICE CUBES AND SHAKE VIGOROUSLY. TASTE FOR BALANCE. DOUBLE-STRAIN INTO A TUMBLER OVER FRESH ICE.

DANDELION-GREEN JUICE: Add 25 to 30 dandelion leaves to a juicer or food processor and slowly add 1 pint of water. Strain the aerated juice through a fine strainer and refrigerate. Use within 24 hours.

DANDELION-INFUSED COINTREAU: Pour contents of the bottle into a separate glass container. Add 15 to 20 yellow dandelion heads, and let infuse at room temperature for 24 hours or until bright yellow.

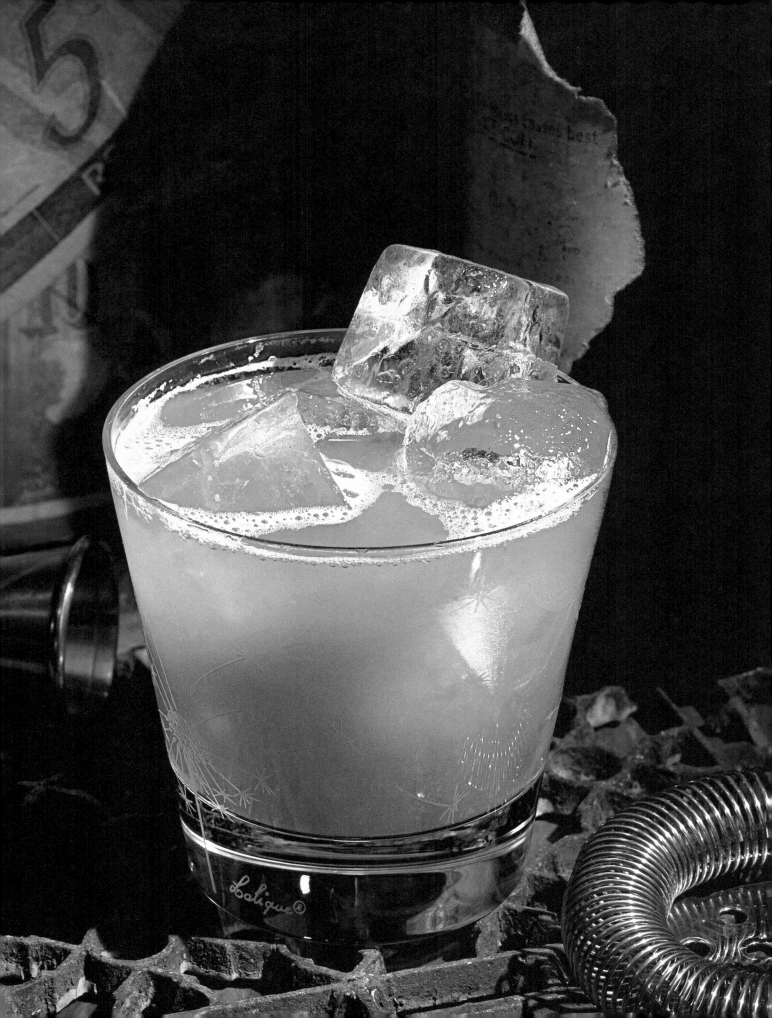

PLYMOUTH ROCKS

BASE SPIRIT: Gin // MODIFIERS: Fino Sherry & Lillet Blanc

1 oz. LA INA FINO **SHERRY**

1 oz. LILLET BLANC

2 oz. PLYMOUTH **GIN**

1 DASH REGAN's **ORANGE** BITTERS NO. 6

GARNISH: FROZEN RIVER ROCKS & AN ORANGE TWIST

PLACE ALL INGREDIENTS IN A MIXING GLASS. ADD LARGE ICE CUBES AND STIR WELL. TASTE FOR BALANCE. STRAIN, GARNISH BY TWISTING OILS FROM PEEL OVER TOP AND SERVE.

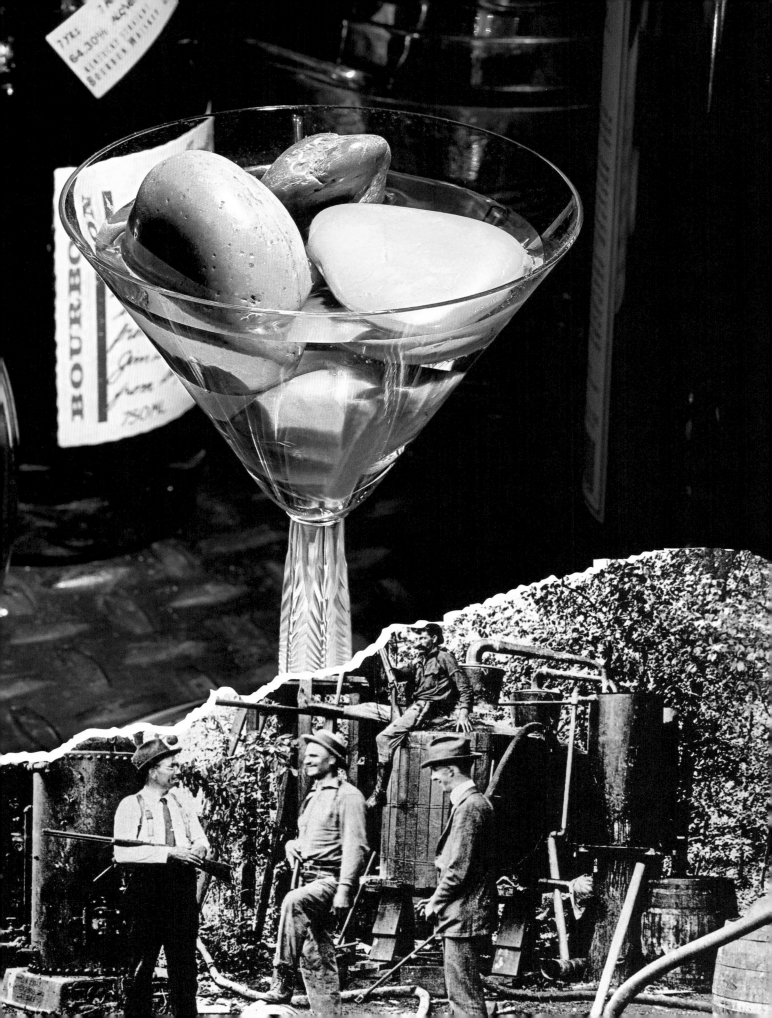

PIÑA PERFECTED

BASE SPIRIT: Extra Añejo Tequila // MODIFIER: Dry Aguardiente

1 1/4 oz. FRESH PINEAPPLE JUICE

1/4 oz. FRESH LIME JUICE

1/4 oz. DEMERERA-SUGAR SYRUP

2 CUBES DARK-ROASTED PINEAPPLE (SEE BELOW)

1 SPRIG FRESH ROSEMARY

1/4 oz. CRISTAL SECO AGUARDIENTE

1 oz. CASA DRAGONES BLENDED BLANCO
& EXTRA AÑESO TEQUILA

DARK-ROASTED PINEAPPLE:
Cut 2 one-by-one-inch cubes from
a pineapple, and caramelize them
on a medium-hot skillet until they are
dark roasted.

GARNISH: 1 ROSEMARY SPRIG & A LIME WEDGE

REMOVE LEAVES FROM ROSEMARY SPRIG AND DISCARD STEM.
PLACE ALL NONALCOHOLIC INGREDIENTS IN A MIXING GLASS.
MUDDLE ROSEMARY AND PINEAPPLE CHUNKS LIGHTLY.
ADD AGUARDIENTE AND TEQUILA. ADD LARGE ICE
CUBES AND SHAKE VIGOROUSLY. TASTE FOR
BALANCE. DOUBLE-STRAIN INTO A GLASS OVER
FRESH ICE (DISCARDING PINEAPPLE CHUNKS), GARNISH, AND SERVE.

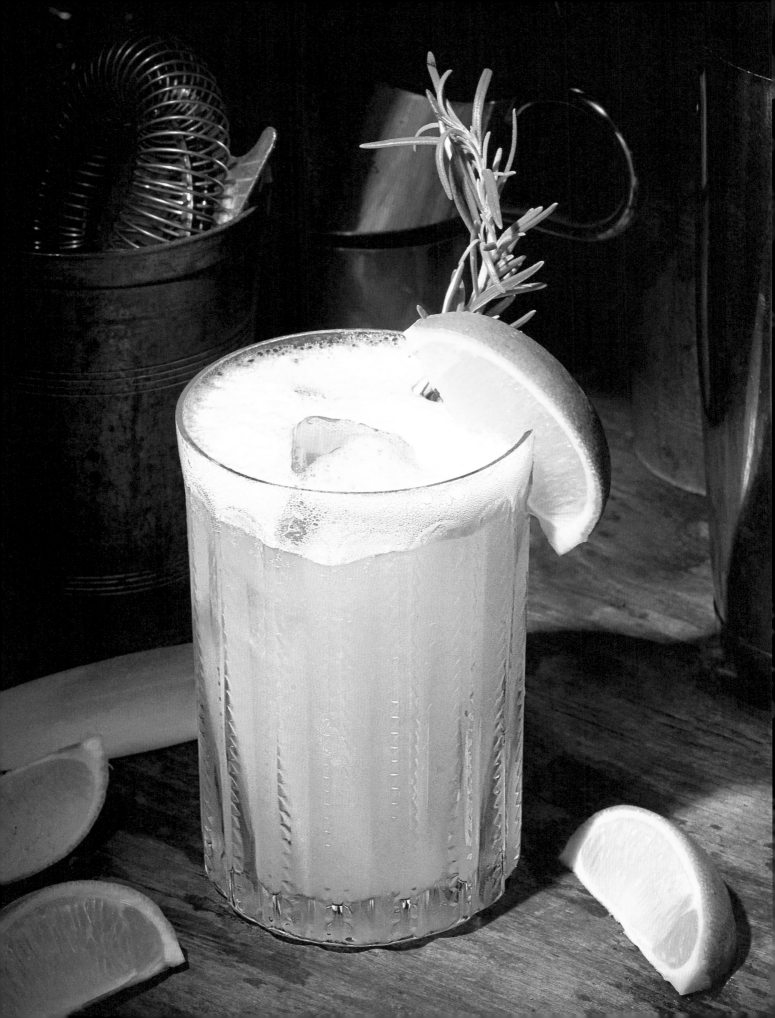

DEMETER'S DAUGHTER

BASE SPIRIT: White Whiskey // MODIFIERS: Cherry Liqueur,
Pomegranate Liqueur, & Ginger Liqueur

1 oz. DEATH'S DOOR WHITE WHISKEY

1/4 oz. FRESH LEMON JUICE

1/4 oz. HEERING CHERRY LIQUEUR

1/4 oz. PAMA POMEGRANATE LIQUEUR

1/4 oz. DOMAINE DE CANTON GINGER LIQUEUR

2 oz. POM WONDERFUL 100% POMEGRANATE JUICE

2 DASHES FEE BROTHERS WHISKEY-BARREL AGED BITTERS

GARNISH: 6 POMEGRANATE SEEDS, SLICE OF CANDIED GINGER, & A COCKTAIL UMBRELLA

PLACE ALL INGREDIENTS IN A MIXING GLASS. ADD LARGE ICE CUBES AND SHAKE VIGOROUSLY. TASTE FOR BALANCE. DOUBLE-STRAIN OVER FRESH ICE INTO A GLASS, GARNISH, AND SERVE.

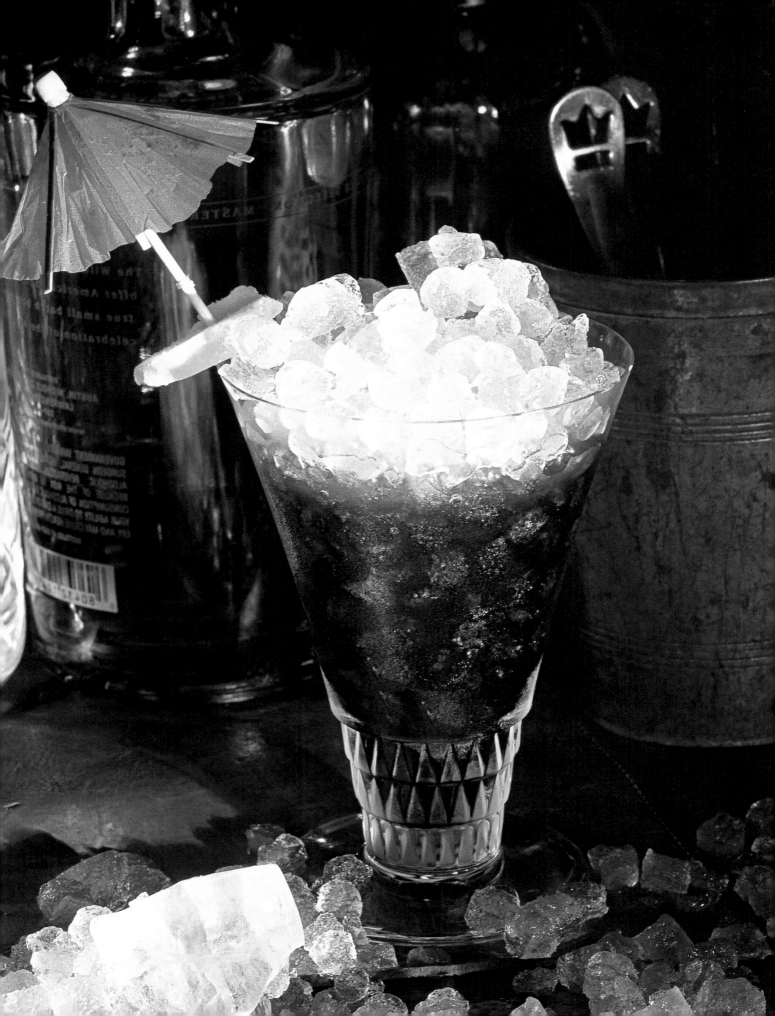

PADDINGTON

BASE SPIRIT: Rum // MODIFIERS: Lillet Blanc & Absinthe Rinse

St GEORGE GREEN ABSINTHE

1/2 oz. FRESH GRAPEFRUIT JUICE

1/2 oz. FRESH LEMON JUICE

1/2 oz. LILLET BLANC

1 1/2 oz. BANKS 5 ISLAND RUM

1 tsp. BONNE MAMAN ORANGE MARMELADE

GARNISH: GRAPEFRUIT TWIST

CHILL A COUPE AND RINSE WITH ABSINTHE. PLACE ALL OTHER INGREDIENTS
IN A MIXING TIN. ADD LARGE ICE CUBES AND SHAKE VIGOROUSLY.
TASTE FOR BALANCE. DOUBLE-STRAIN INTO THE COUPE, GARNISH, AND SERVE.

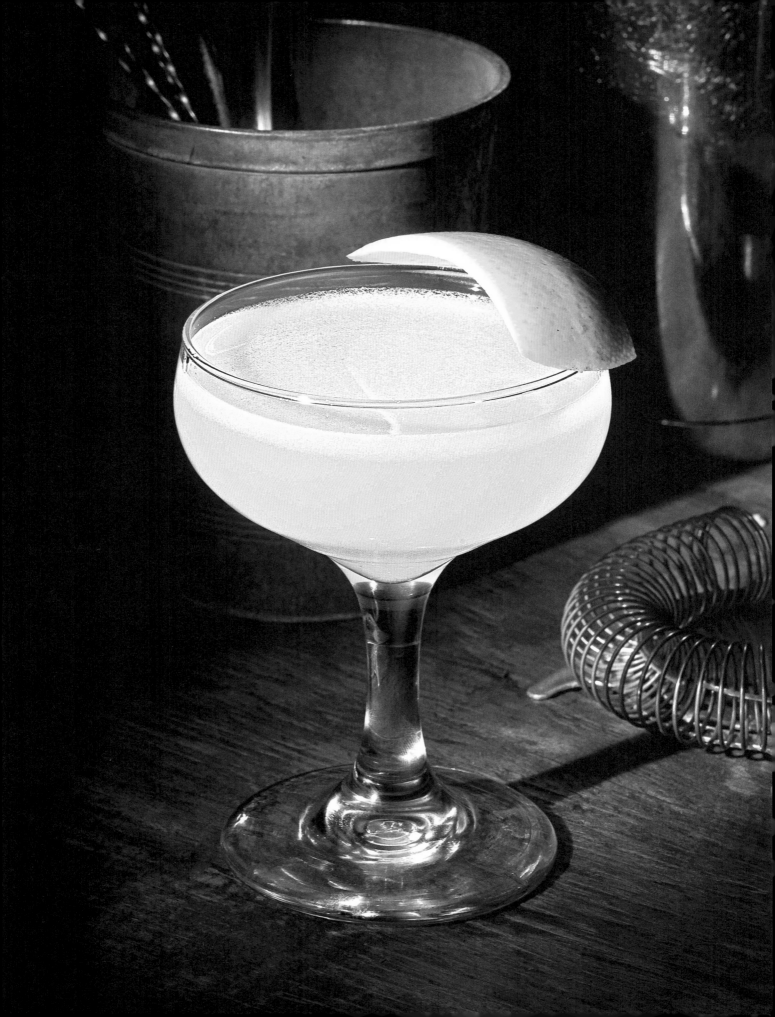

MEZCAL MULE

BASE SPIRIT: Mezcal

3/4 oz. FRESH LIME JUICE

3 SLICES CUCUMBER

3/4 oz. BOIRON PASSION-FRUIT PUREE

1/2 oz. AGAVE SYRUP

1 oz. HOUSE-MADE GINGER BEER (SEE BELOW)

1 1/2 oz. SOMBRA MEZCAL

PLACE LIME JUICE AND CUCUMBER SLICES IN A MIXING GLASS, MUDDLE. ADD REMAINING INGREDIENTS. ADD LARGE ICE CUBES AND SHAKE VIGOROUSLY. TASTE FOR BALANCE. DOUBLE-STRAIN INTO A GLASS OVER FRESH ICE. GARNISH, AND SERVE

GARNISH: A SLICE CUCUMBER, 1 PIECE CANDIED GINGER, & A PINCH OF GROUND CHILI POWDER

HOUSE-MADE GINGER BEER:

2½ quarts of water
1 cup freshly minced ginger
1 oz. fresh lime juice,
2 oz. light brown sugar

Bring the water to a boil, then turn off heat. Add the ginger and cover. Let sit for 1 hour, then strain the mixture through a chinois. (Press down on the ginger with the back of a spoon to force the liquid through the fine mesh.) Add the lime juice and sugar, then stir, bottle, and refrigerate.

Yield: 77 oz.

34

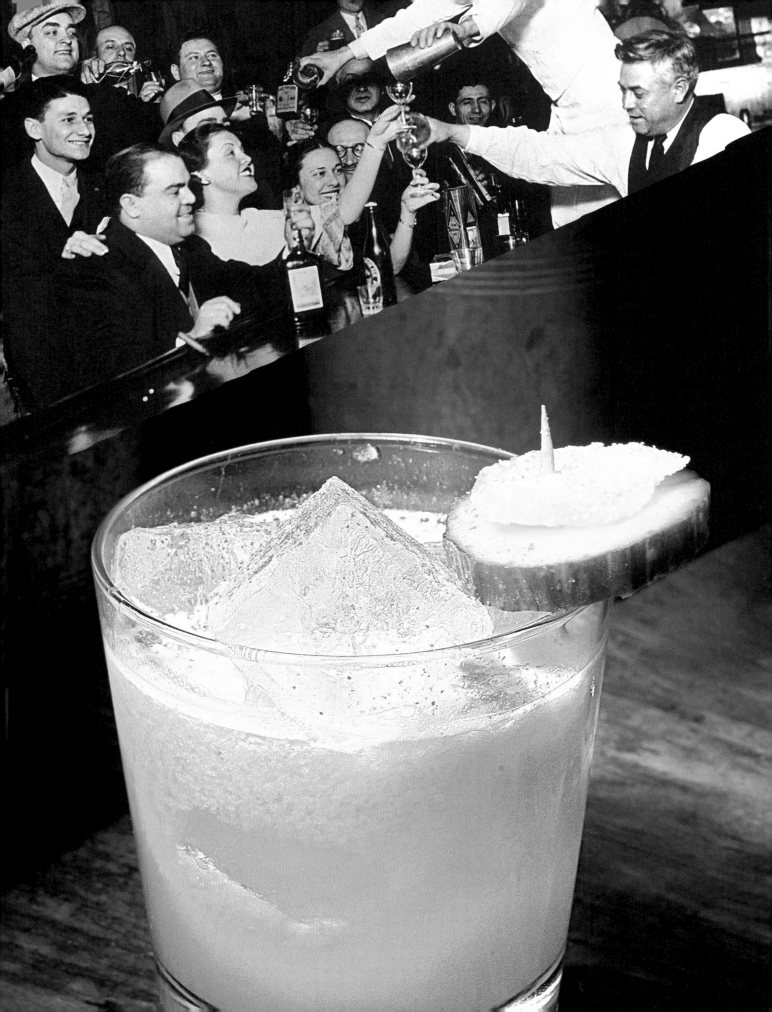

THE SLOPE

BASE SPIRIT: Rye Whiskey // MODIFIERS: Vermouth & Apricot Brandy

2 DASHES ANGOSTURA BITTERS

1/4 OZ. APRICOT BRANDY

1 OZ. PUNT E MES SWEET VERMOUTH

2 OZ. RITTENHOUSE RYE

GARNISH: BRANDY-SOAKED CHERRIES

PLACE ALL INGREDIENTS IN A MIXING GLASS.
ADD LARGE ICE CUBES AND STIR THOROUGALY.
TASTE FOR BALANCE.
SINGLE-STRAIN INTO A MARTINI GLASS,
TAKING CARE NOT TO AERATE.
GARNISH AND SERVE.

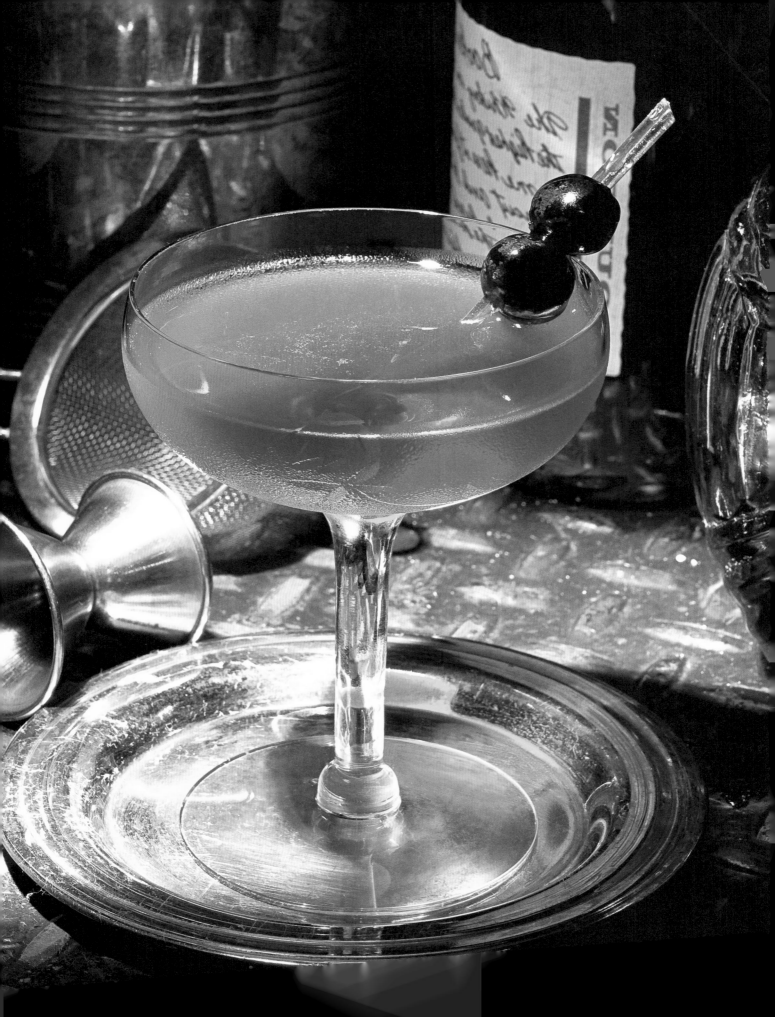

THE C. WONDER COCKTAIL

BASE SPIRIT: Gin // MODIFIERS: Cointreau & Prosecco

1/4 oz. FRESH LEMON JUICE

1/2 oz. SUPERFINE CANE-SUGAR SIMPLE SYRUP

1/2 oz. TANQUERAY No. TEN GIN

1/4 oz. COINTREAU

1 tsp. LEMON VERBENA TEA

3 FRESH BASIL LEAVES

2 oz. ZARDETTO PROSECCO

──── GARNISH: BASIL LEAF ────

PLACE ALL INGREDIENTS EXCEPT PROSECCO IN A MIXING TIN.
MUDDLE TEA AND BASIL LEAVES UNTIL BRUISED.
ADD LARGE ICE CUBES AND SHAKE VIGOROUSLY.
TASTE FOR BALANCE. POUR CONTENTS DIRECTLY INTO A FLUTE.
TOP WITH PROSECCO. GENTLY MIX WITH A BAR SPOON
BY STIRRING AND PULLING. GARNISH AND SERVE.

In 2012, I was asked to do a book signing at a women's-apparel and modern-home-decor store. At the time, I had never heard of C. Wonder but I was only too delighted to create a signature cocktail for the company.

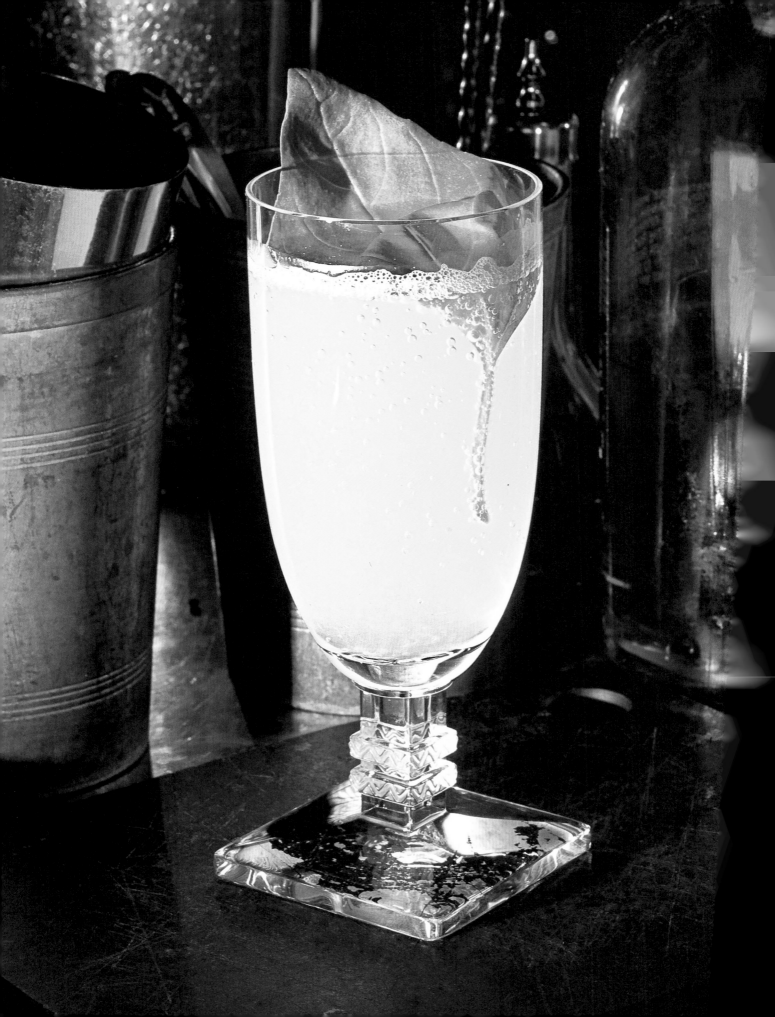

CRAZY CAPRESE COCKTAIL

BASE SPIRIT: Basil Vodka // MODIFIER: Dry Vermouth

1 1/2 oz. TOMATO WATER
(ROASTED, SQUEEZED, AND STRAINED FRESH ROMA TOMATOES)

2 oz. SQUARE ONE BASIL VODKA

1/4 oz. VYA DRY VERMOUTH

1/4 oz. CANE-SUGAR SIMPLE SYRUP

3 FRESH BASIL LEAVES

GARNISH: RIM GLASS WITH BALSAMIC GLAZE,
EXTRA VIRGIN OLIVE OIL FOAM (MADE USING FOAM
SIPHON), 1 YELLOW CHERRY TOMATO,
1 MOZZARELLA BALL, & 1 RED CHERRY
TOMATO SKEWERED ON A COCKTAIL PICK
1 BASIL LEAF

ADD ALL INGREDIENTS TOGETHER IN A MIXING GLASS
AND MUDDLE BASIL LEAVES. ADD LARGE ICE CUBES
AND STIR. TASTE FOR BALANCE. DOUBLE-STRAIN INTO
RIMMED GLASS. GARNISH WITH FOAM, THEN TOMATOES,
MOZZARELLA, AND BASIL, SERVE.

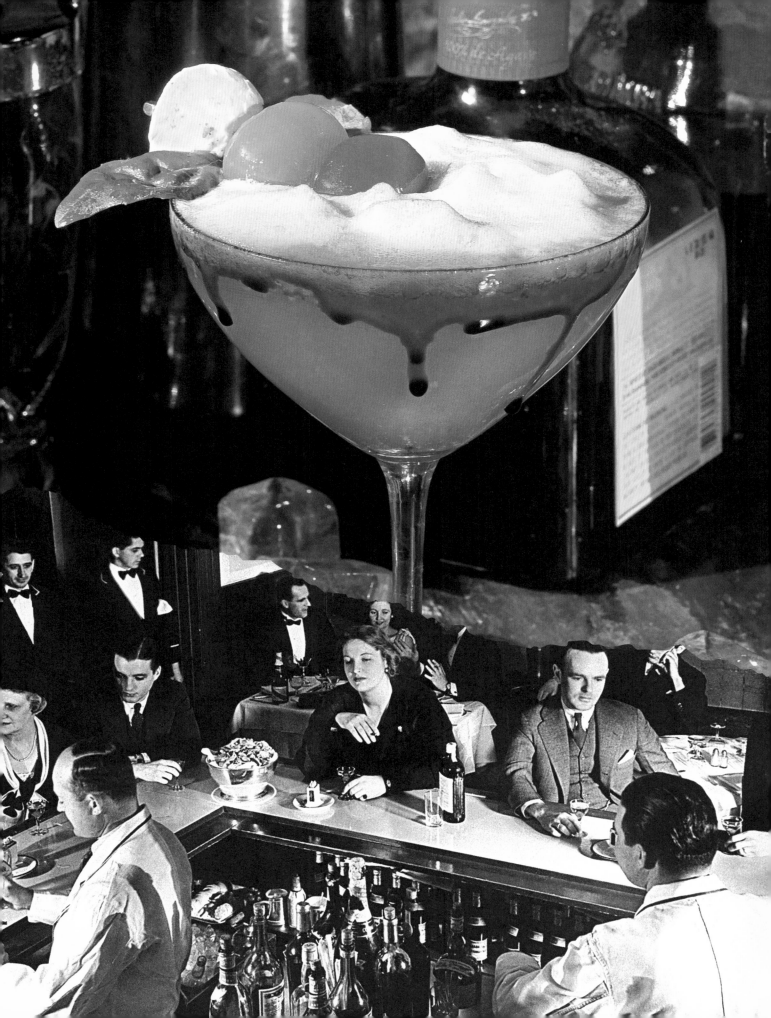

INSATIABLE GAEL

BASE SPIRIT: Aged Rum // MODIFIERS: Mandarine Liqueur, Dark Rum, & Champagne

1/2 oz. FRESH TANDARIN ORANGE Juice

1/2 oz. FRESH PASSION-FRUIT Puree

1/4 oz. FRESH LIME Juice

1/4 oz. DEMERARA-SUGAR SYRUP

1/4 oz. MANDARINE NAPOLÉON Liqueur

1/4 oz. MYER'S DARK RUM

1 oz. RUM SIXTY-SIX TROPICAL·RESERVE

2 oz. NV PIERRE GIMONNET CHAMPAGNE

GARNISH: MANDARIN-ORANGE ZEST

PLACE ALL INGREDIENTS EXCEPT CHAMPAGNE IN A MIXING TIN. ADD LARGE ICE CUBES AND SHAKE VIGOROUSLY. DOUBLE-STRAIN DIRECTLY INTO A GLASS. ADD CHAMPAGNE VERY SLOWLY. TASTE FOR BALANCE. SLOWLY MIX WITH A BAR SPOON BY STIRRING AND PULLING. GARNISH AND SERVE.

This cocktail was named after the insatiable food critic Gael Greene.

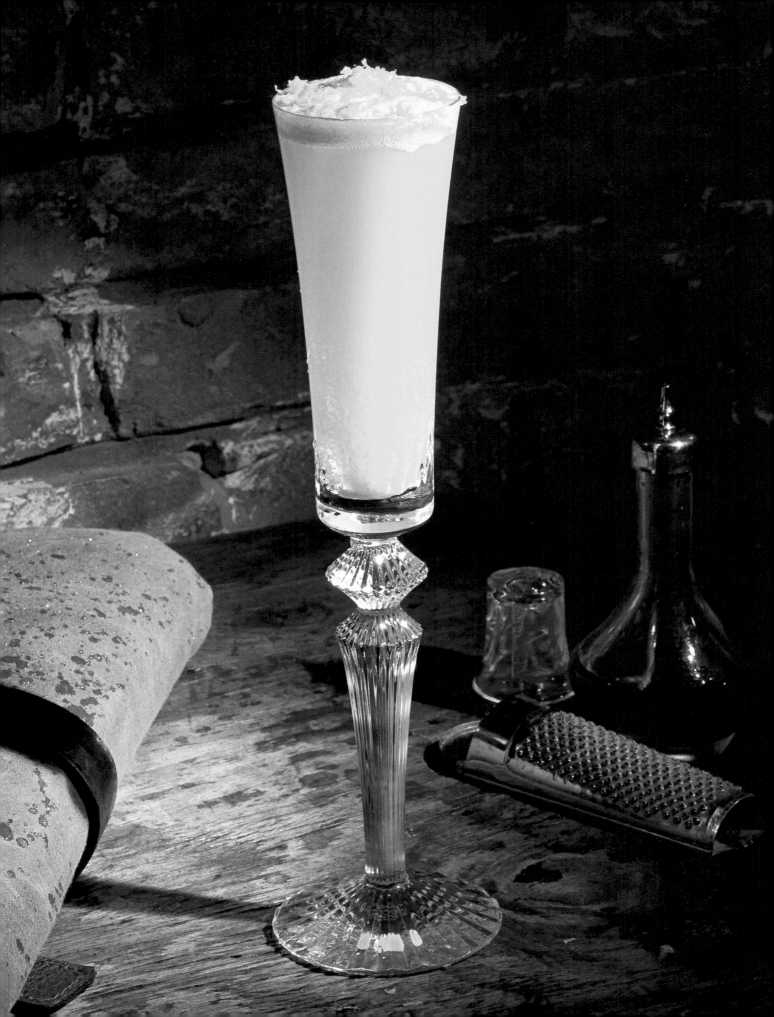

VALRHONA KISS

BASE SPIRIT: Cognac // MODIFIER: Oloroso Sherry

½ oz. **VALRHONA BITTER CHOCOLATE** SYRUP

½ oz. HALF-AND-HALF (OR WHOLE MILK)

½ oz. CANE-SUGAR SIMPLE SYRUP

¼ oz. CONFECTIONARY CARAMEL

1¼ oz. HENNESSY V.S.O.P. COGNAC

1 oz. LUSTAU ALMACENISTA OLOROSO SHERRY

2 DASHES MEXICAN MOLE BITTERS

GARNISH: RIM EDGE OF GLASS WITH COCOA POWDER & GROUND NUTMEG

PLACE ALL INGREDIENTS IN A COCKTAIL TIN AT ROOM TEMPERATURE AND DRY-SHAKE VIGOROUSLY. ADD LARGE ICE CUBES AND SHAKE AGAIN. TASTE FOR BALANCE. RIM GLASS, DOUBLE-STRAIN, AND SERVE.

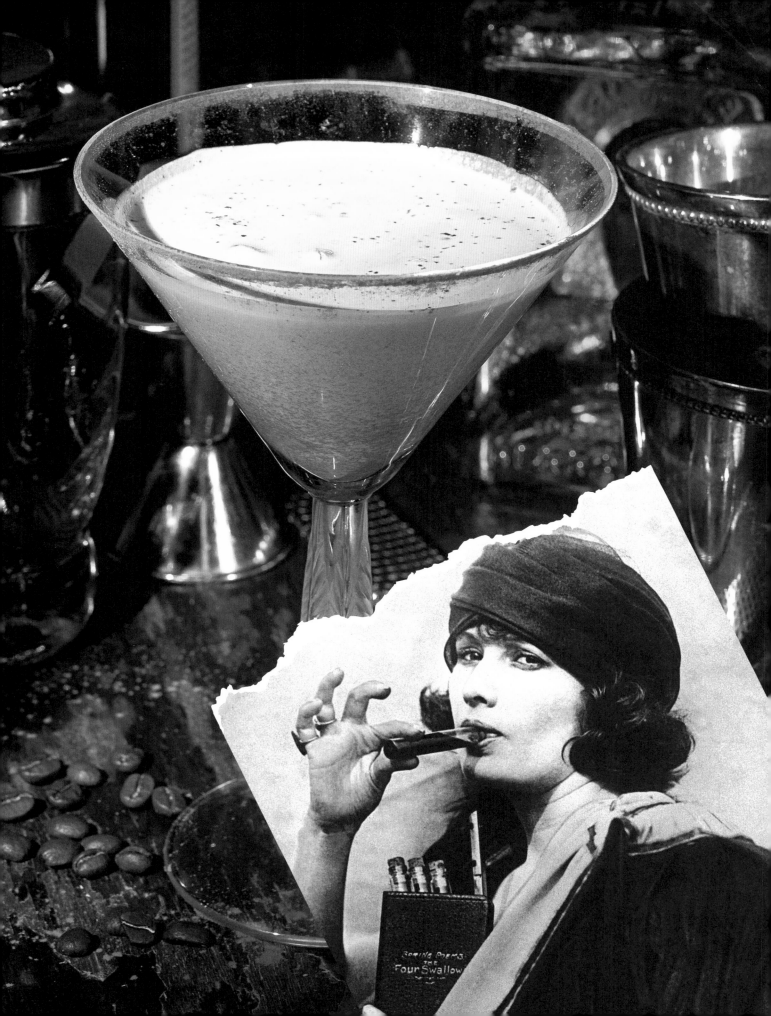

CHAI TAI

BASE SPIRIT: Aged Rum
MODIFIERS: Dark Rum, Orgeat, & Curacao

1/4 oz. FRESH KEY-LIME JUICE (NORTH AMERICA)

1/2 oz. CANE-SUGAR SIMPLE SYRUP (AFRICA)

1 1/2 oz. CHAI TEA (ASIA)

1/4 oz. MONIN ORGEAT SYRUP (EUROPE)

1/4 oz. CURACAO (CARIBBEAN)

1 oz. SANTA TERESA 1796 ANTIGUO DE SOLERA RUM (SOUTH AMERICA)

1 THREE-INCH LEMONGRASS STICK (ASIA)

5 SPEARMINT LEAVES (AUSTRALIA)

1/4 oz. GOSLING'S BLACK SEAL BERMUDA BLACK RUM (CARIBBEAN)

GARNISH: MINT SPRIG & A FIVE-INCH LEMONGRASS STICK (WHEN IN SEASON)

PLACE ALL INGREDIENTS EXCEPT GOSLING'S RUM IN A MIXING GLASS. MUDDLE THE LEMONGRASS AND SPEARMINT LEAVES. ADD LARGE ICE CUBES AND SHAKE VIGOROUSLY. TASTE FOR BALANCE. DOUBLE-STRAIN INTO A GLASS OVER FRESH ICE (ANTARCTICA). USE A BAR SPOON TO FLOAT THE GOSLING'S RUM ON TOP. GARNISH AND SERVE.

The World ship is the world's first floating luxury community, and this cocktail was created onboard. The ship travels the world to places that many cruise ships would never go, allowing access to fresh produce in every market on the planet.

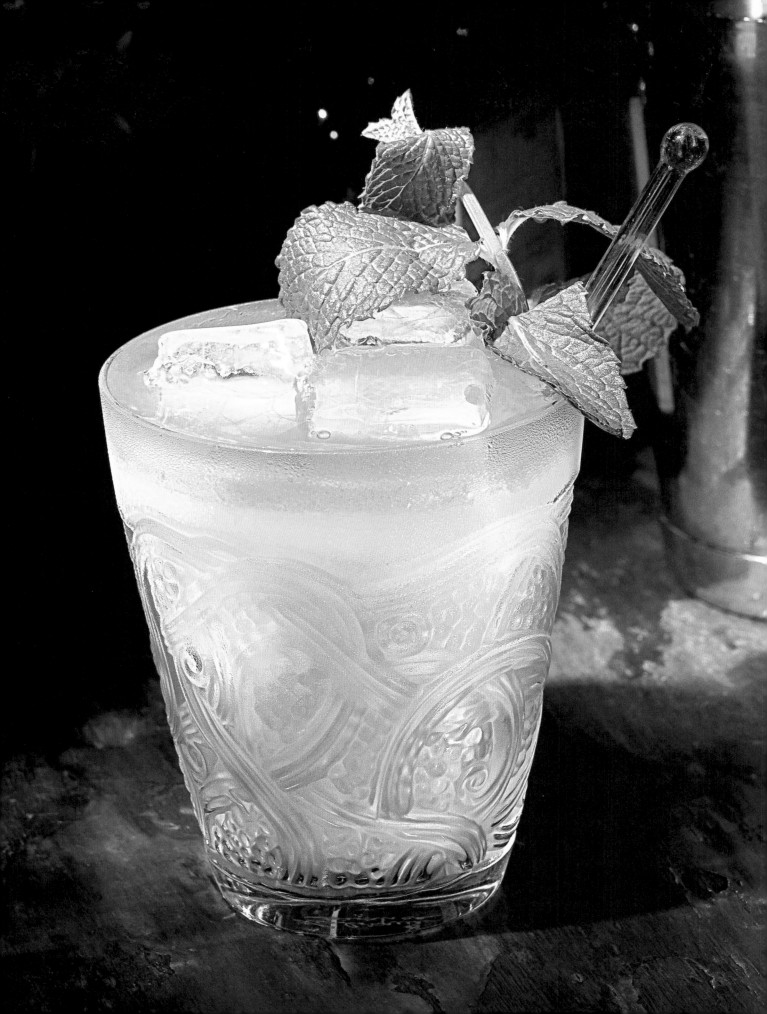

AMIGO AÑEJO

BASE SPIRIT: Añejo Tequila // MODIFIERS: Sweet Vermouth & Maraschino Liqueur

2 DASHES DALE DEGROFF'S PIMENTO AROMATIC BITTERS

1 ¹⁄₂ OZ. CARPANO ANTICA SWEET VERMOUTH

2 ¹⁄₂ OZ. DON JULIO AÑEJO TEQUILA

OPTIONAL: If you are a bourbon lover and you find this recipe a tad dry for your palate, add just a drop (no more) of agave nectar.

GARNISH: REHYDRATED MARASCHINO LIQUEUR -SOAKED DRIED CHERRIES

PLACE ALL INGREDIENTS IN A MIXING GLASS. ADD LARGE ICE CUBES AND STIR THOROUGHLY. TASTE FOR BALANCE. SINGLE-STRAIN INTO A GLASS, GARNISH, AND SERVE.

REHYDRATED MARASCHINO LIQUEUR-SOAKED DRIED CHERRIES: Add 8 oz. dried cherries to 1 cup boiling water. Add 1 oz. maraschino liqueur. Remove from heat and let stand until cooled to room temperature. Refrigerate until used.

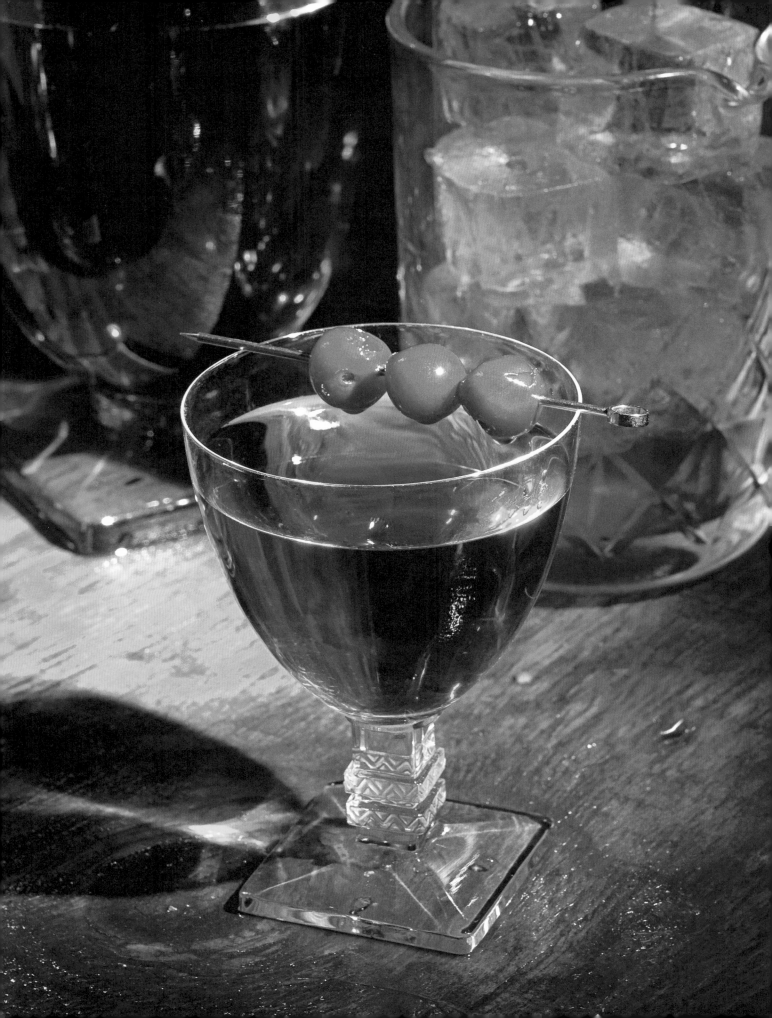

PARADIGM SHIFT

BASE SPIRIT: Añejo Claro Tequila // MODIFIERS: Bärenjäger Honey Liqueur & Moscato d'Asti

1 oz. FRESH HONEY DEW -MELON JUICE

1/4 oz. FRESH LIME JUICE

1/4 oz. VANILLA-BEAN-INFUSED
CLOVER HONEY SYRUP

1/4 oz. BÄRENJÄGER
HONEY LIQUEUR

1 1/4 oz. DON JULIO 70 AÑEJO CLARO TEQUILA

1 oz. MOSCATO D'ASTi

GARNISH: HORSE-HEAD LIME PEEL WITH WEDGE OF HONEY DEW MELON
OR FRESH HONEYSUCKLE FLOWER (WHEN IN SEASON)

PLACE ALL INGREDIENTS EXCEPT MOSCATO
D'ASTI IN A MIXING GLASS.
ADD LARGE ICE CUBES AND SHAKE VIGOROUSLY.
DOUBLE-STRAIN DIRECTLY INTO A GLASS
OVER FRESH ICE. ADD MOSCATO D'ASTI.
TUMBLE ROLL BACK AND FORTH 1 TIME.
TASTE FOR BALANCE. GARNISH AND SERVE.

VANILLA BEAN-INFUSED HONEY SYRUP: Add 16 oz. of hot water to 1 liter bottle. Add 16 oz. of clover honey and mix until honey is completely emulsified. Take 1 Madagascar vanilla bean and slice down the middle. Place both halves into bottle with syrup and let infuse for at least 3 hours at room temperature. Refrigerate.

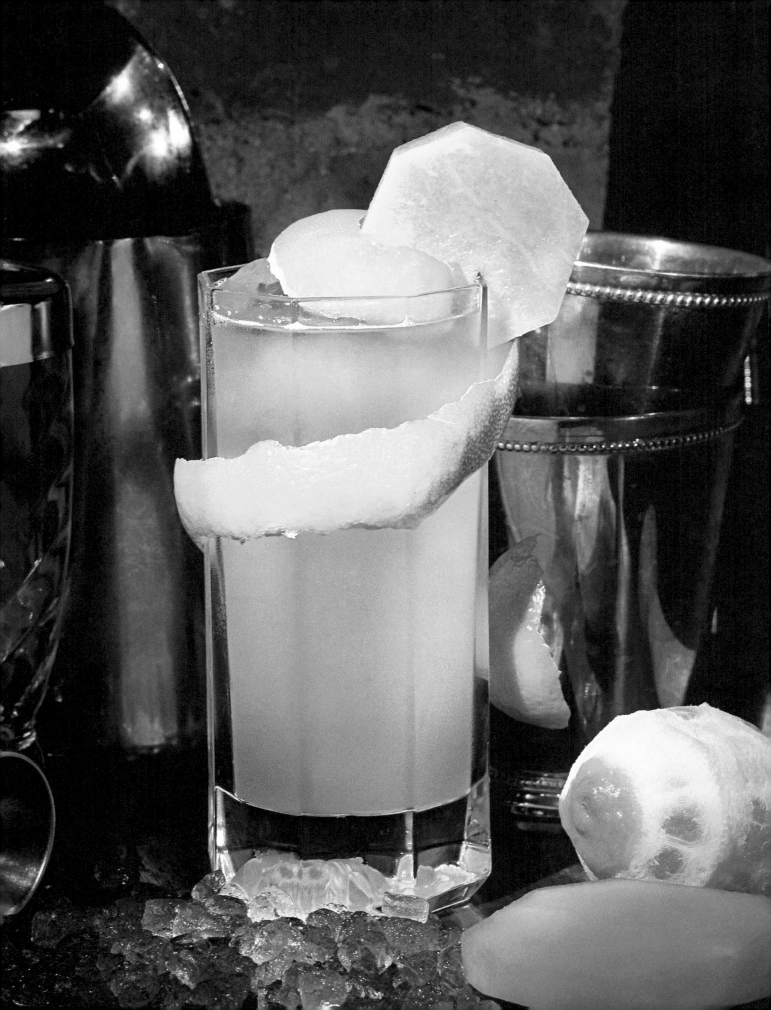

FRESA BRAVA

BASE SPIRIT: Infused Tequila // MODIFIER: Yellow Chartreuse

1 STRAWBERRY

1/2 oz. CANE-SUGAR SIMPLE SYRUP

3/4 oz. FRESH LEMON JUICE

3/4 oz. YELLOW CHARTREUSE

2 oz. MUESTRA No. OCHO
BLANCO JALAPEÑO-INFUSED TEQUILA

MUDDLE STRAWBERRY WITH SYRUP AND JUICE IN A MIXING GLASS. ADD ALL REMAINING INGREDIENTS TO THE MIXING GLASS. ADD LARGE ICE CUBES AND SHAKE VIGOROUSLY. TASTE FOR BALANCE. DOUBLE-STRAIN INTO A COUPE AND SERVE.

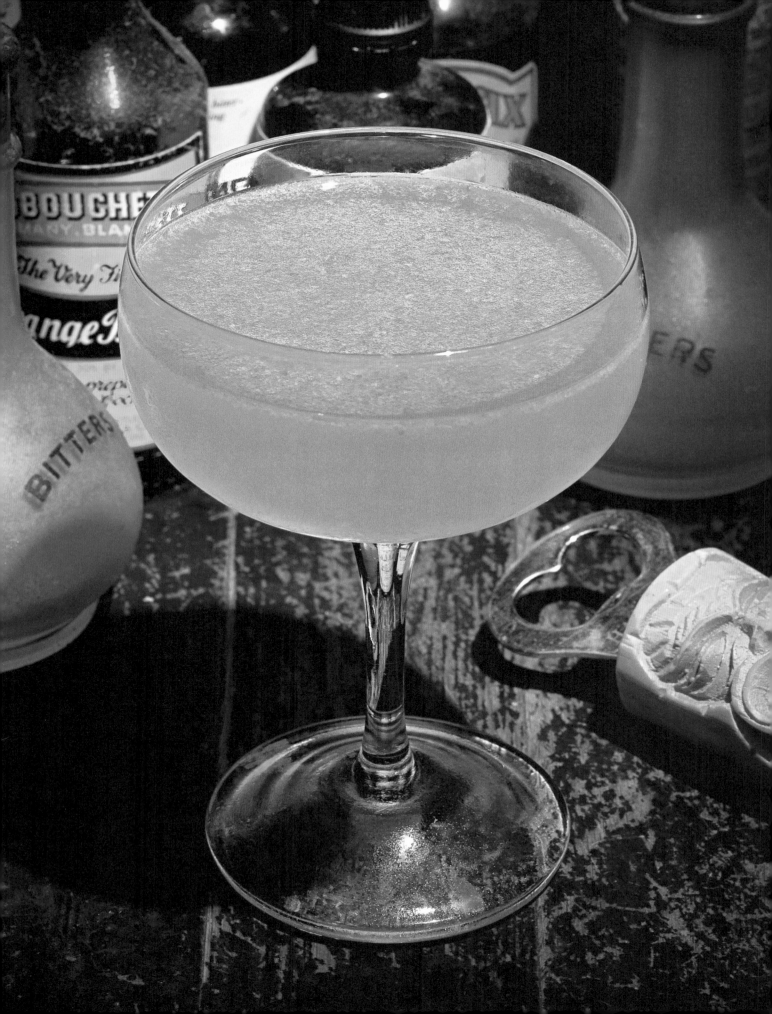

QUEEN BEE COCKTAIL

BASE SPIRIT: Tennessee Honey Whiskey // MODIFIER: Bärenjäger Honey Liqueur

1 oz. FRESH LIME JUICE

1 oz. CLOVER-HONEY SYRUP

½ oz BÄRENJÄGER HONEY LIQUEUR

5 MINT LEAVES

2 DASHES FEE BROTHERS MINT BITTERS

1 ½ oz. JACK DANIEL'S TENNESSEE HONEY WHISKEY

GARNISH: FRESHLY SPANKED LARGE MINT SPRIG & LIME WEDGE

PLACE ALL INGREDIENTS EXCEPT HONEY WHISKEY IN A MIXING GLASS; MUDDLE MINT. ADD HONEY WHISKEY. ADD LARGE ICE CUBES AND SHAKE VIGOROUSLY. TASTE FOR BALANCE. DOUBLE-STRAIN INTO A TUMBLER OVER CRUSHED ICE, GARNISH, AND SERVE.

NOTE: Spanking mint (or other herbs) is exactly what it sounds like. By placing the leaves in your hand and literally slapping them with your other hand, they flatten out and the essential oils are released. This not only brings out the flavor, but it dramatically intensifies the aromatics.

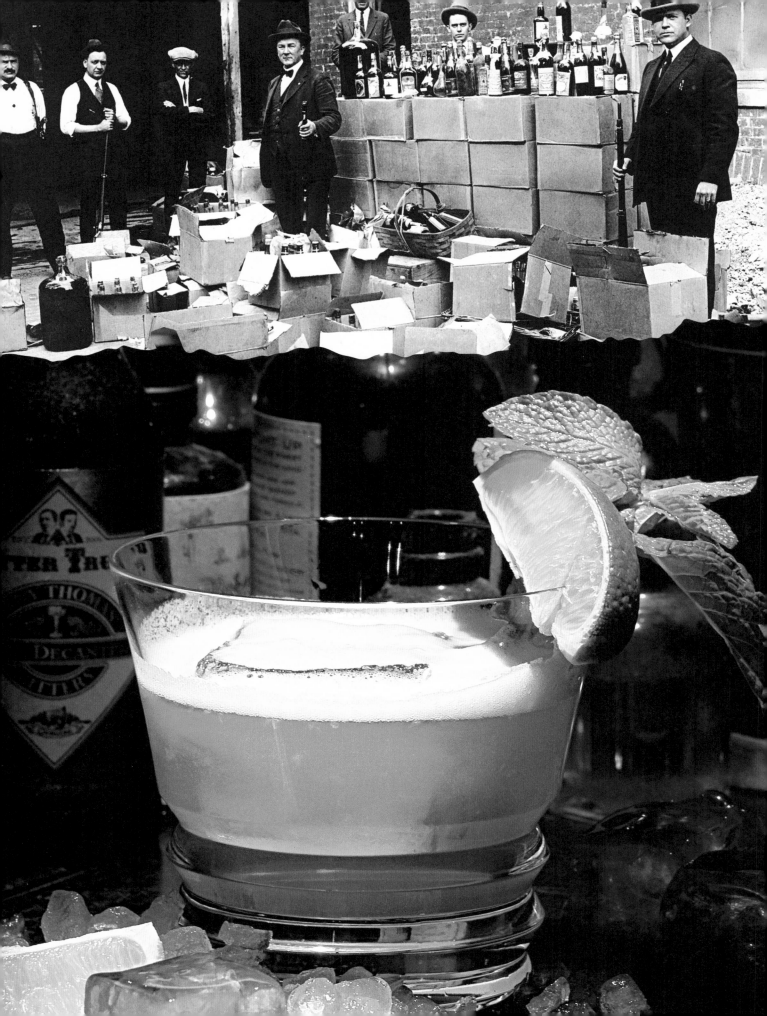

ABCDEF

BASE SPIRITS: Gin, Aperol, & Pisco // MODIFIERS: Dry Vermouth, Campari, & Fernet Branca

1 tsp. FERNET BRANCA

1/4 oz. APEROL

1/2 oz. CAMPARI

1/2 oz. CAMPO DE ENCANTO PISCO

3/4 oz. DOLIN VERMOUTH DE CHAMBÉRY

1 1/2 oz. BEEFEATER GIN

CHILL A COCKTAIL COUPE.
PLACE ALL INGREDIENTS IN A MIXING GLASS.
ADD LARGE ICE CUBES AND STIR THOROUGHLY.
TASTE FOR BALANCE.
SLOWLY POUR FROM MIXING GLASS,
TAKING CARE NOT TO AERATE. SERVE.

This cocktail was named after the first letter of each spirit in the recipe.

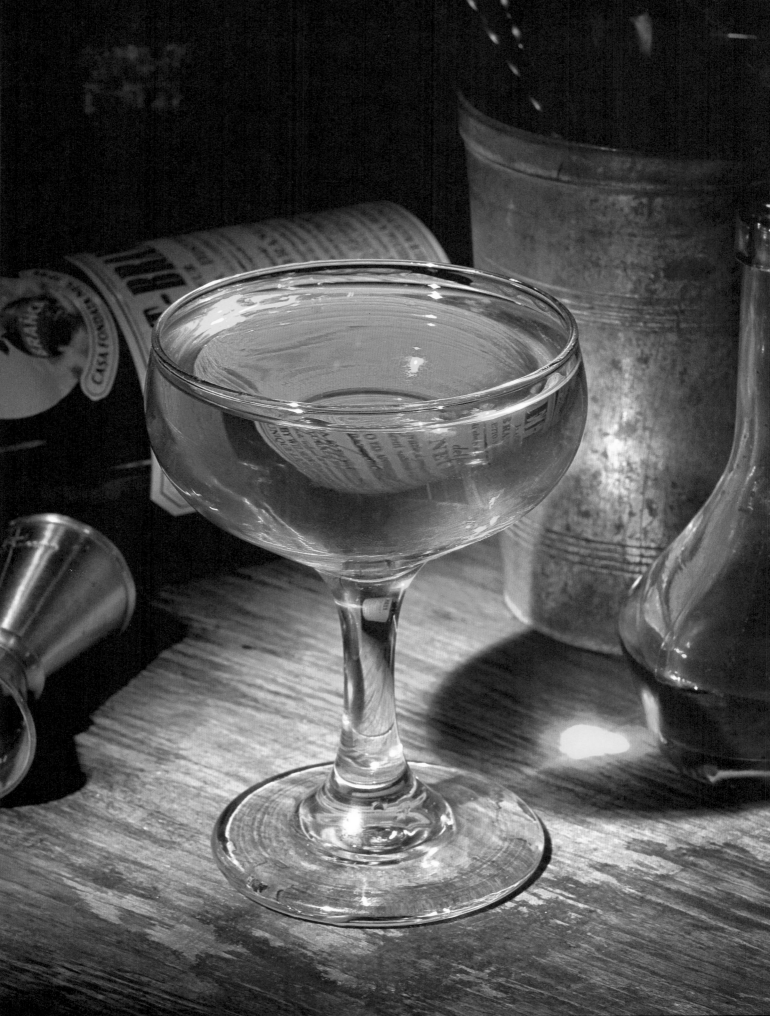

DRINK RESPONSIBLY

BASE SPIRITS: Vodka, Gin, Tequila, & Rum // MODIFIER: Grand Marnier 100

3/4 oz. FRESH LEMON JUICE

1 oz. CANE-SUGAR SIMPLE SYRUP

1/4 oz. GRAND MARNIER CUVÉE
DU CENTENAIRE (GM 100)

1/2 oz. KETEL ONE VODKA

1/4 oz. TANQUERAY NO. TEN GIN

1/4 oz. DON JULIO BLANCO TEQUILA

1/4 oz. ORONOCO RUM

1 oz. GUS (GROWN-UP SODA) DRY COLA

GARNISH: LEMON WEDGE

PLACE ALL INGREDIENTS EXCEPT SODA IN A MIXING GLASS.
ADD LARGE ICE CUBES AND SHAKE VIGOROUSLY.
ADD SODA AND TUMBLE ROLL BACK AND FORTH 1 TIME.
TASTE FOR BALANCE. DOUBLE-STRAIN INTO A HIGHBALL GLASS
OVER ICE, GARNISH, AND SERVE.

This is a variation on a Long Island Iced Tea; while not as strong, it tastes phenomenal.

MATAHARI

BASE SPIRIT: Cognac // MODIFIER: Chai-Infused Sweet Vermouth

1/2 OZ. RICH CANE-SUGAR SIMPLE SYRUP 2:1

3/4 OZ. POM WONDERFUL 100% POMEGRANATE JUICE

3/4 OZ. FRESH LEMON JUICE

1 OZ. CHAI-INFUSED SWEET VERMOUTH (SEE BELOW)

1 1/2 OZ. PIERRE FERRAND AMBRE 10-YEAR COGNAC

PLACE ALL INGREDIENTS IN A MIXING GLASS. ADD LARGE ICE CUBES. SHAKE VIGOROUSLY. TASTE FOR BALANCE. DOUBLE-STRAIN INTO A CHILLED COUPE, GARNISH, AND SERVE.

GARNISH: 3 DRIED ROSEBUDS

CHAI-INFUSED SWEET VERMOUTH:

4 green-cardamom pods	1 tbsp. peeled, coarsely chopped ginger root
4 whole cloves	1 tbsp. loose-leaf chai
1 cinnamon stick	1 liter bottle Cinzano Rosso sweet vermouth

Place cardamom, cloves, cinnamon, and ginger in a small saucepan over low heat for 2 minutes. Remove; let cool for 1 minute. Add tea and 1 cup of the vermouth. Bring to a low boil and simmer for 2 minutes. Remove from heat; let cool completely. Add the remaining vermouth and strain through a cheesecloth back into the bottle. Label bottle and store at room temperature.
Yield: 1 quart

A Tonic with Gin

BASE SPIRIT: Gin

1/16 tsp. RAW QUININE POWDER

1 oz. FRESH LIME JUICE

1 1/2 oz. CANE-SUGAR SIMPLE SYRUP

1 1/2 oz. TANQUERAY No. TEN GIN

1/2 oz. SPARKLING WATER

GARNISH: LIME WEDGE WITH STIR STICK

PLACE ALL INGREDIENTS EXCEPT SPARKLING WATER IN A MIXING TIN. DRY-SHAKE VIGOROUSLY WITHOUT ICE, TO EMULSIFY POWDER IN ALCOHOL. FILL A HIGHBALL WITH ICE. POUR CONTENTS OF MIXING TIN INTO GLASS AND TOP OFF WITH SPARKLING WATER. TUMBLE ROLL BACK AND FORTH 1 TIME, GARNISH, AND SERVE.

A BRIEF HISTORY OF THE GIN AND TONIC: During the British occupation of India and parts of North Africa, soldiers had to ingest quinine powder to prevent malaria. They would stir the bitter red powder with soda siphon water and granulated sugar to make a medicinal beverage called a "tonic." The soldiers decided that if they were forced to drink this medicine, they were going to add some gin. The recipe above closely resembles the original gin and tonic, with one notable addition: ice.

JAPANESE PICKLEBACK

BASE SPIRIT: Japanese Whisky // MODIFIER: Fermented Soy Sauce

1 1/2 oz. CHILLED YAMAZAKI
12-YEAR JAPANESE WHISKY
1/4 oz. CHILLED AGED OR NATURALLY
FERMENTED SOY SAUCE
1 oz. CHILLED McCLURE'S BRINE

GARNISH: SMALL SIDE PICKLE

POUR WHISKY AND SOY SAUCE INTO A LIQUEUR GLASS.
POUR A SIDE SHOT OF PICKLE JUICE.
GARNISH AND SERVE. SIP OR SHOOT WHISKY
IMMEDIATELY AFTER
SWALLOWING, SIP OR SHOOT
PICKLE JUICE. TAKE A BITE OF PICKLE.

The Bushwick Country Club in New York was the first to popularize the Pickleback.

GINGER SMASH

BASE SPIRIT: Gin // MODIFIER: Apple Schnapps

2 SLICES FRESH GINGER ROOT

10 FRESH CRANBERRIES

1 1/2 Tsp. SUPERFINE SUGAR

1 1/2 OZ. PLYMOUTH GIN

1 1/2 OZ. BERENTZEN APFELKORN

3/4 OZ. FRESH LEMON JUICE

MUDDLE GINGER, CRANBERRIES, AND SUGAR
IN THE BOTTOM OF A MIXING GLASS.
ADD GIN, APFELKORN, AND LEMON JUICE.
TASTE FOR BALANCE.
ADD LARGE ICE CUBES AND SHAKE BRIEFLY.
SLOWLY POUR UNSTRAINED,
INTO AN OLD-FASHIONED GLASS; SERVE.

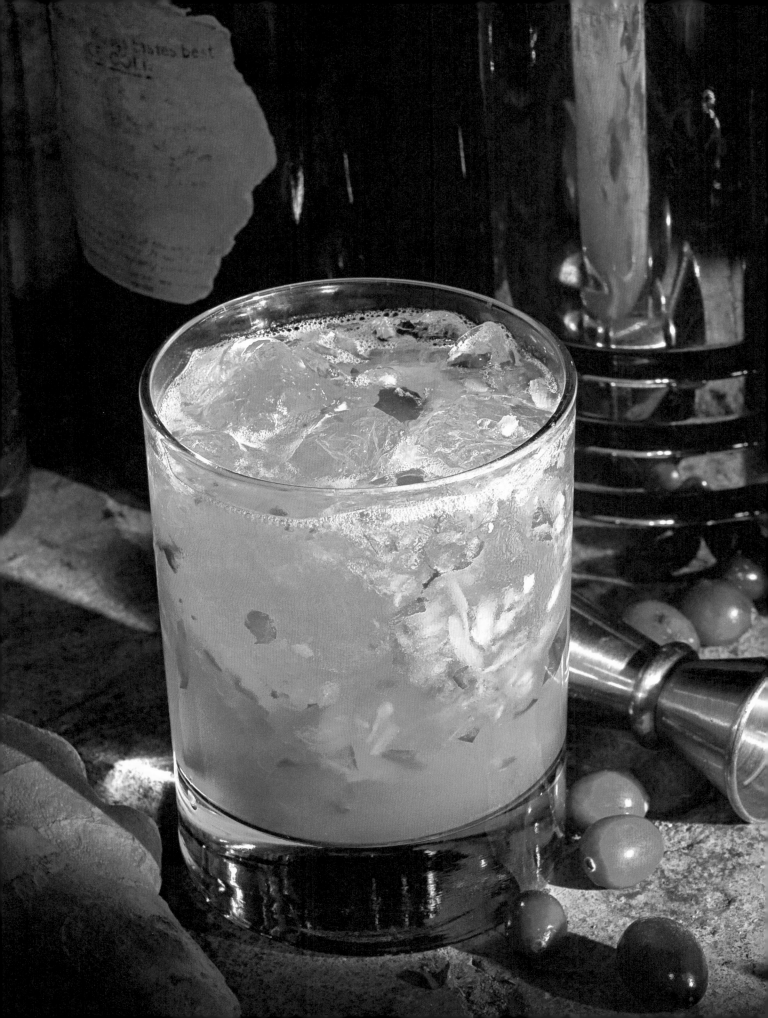

LOVE-DRUNK PUNCH

BASE SPIRIT: Brandy de Jerez // MODIFIER: Oloroso Sherry

2.5 oz. GRADE A CANADIAN MAPLE SYRUP

1.5 oz. FRESH LIME JUICE

2.5 oz. LUSTAU ALMACENISTA OLOROSO DRY SHERRY

2.5 oz. GRAN DUQUE D'ALBA GRAN RESERVA BRANDY DE JEREZ

10 DASHES ANGOSTURA ORANGE BITTERS

1 tsp. GROUND CLOVES

GARNISH: ORANGE WHEELS STUDDED WITH CLOVES

PLACE ALL INGREDIENTS EXCEPT CLOVES IN A PUNCH BOWL. TAKE 1 CUP OF PUNCH AND ADD GROUND CLOVES. DRY-SHAKE VIGOROUSLY IN MIXING TIN, THEN POUR BACK INTO BOWL AND STIR. TASTE FOR BALANCE. GARNISH. ADD 1 HUGE ICE CUBE TO BOWL. LADLE PUNCH INTO GLASSES, GARNISH, AND SERVE.

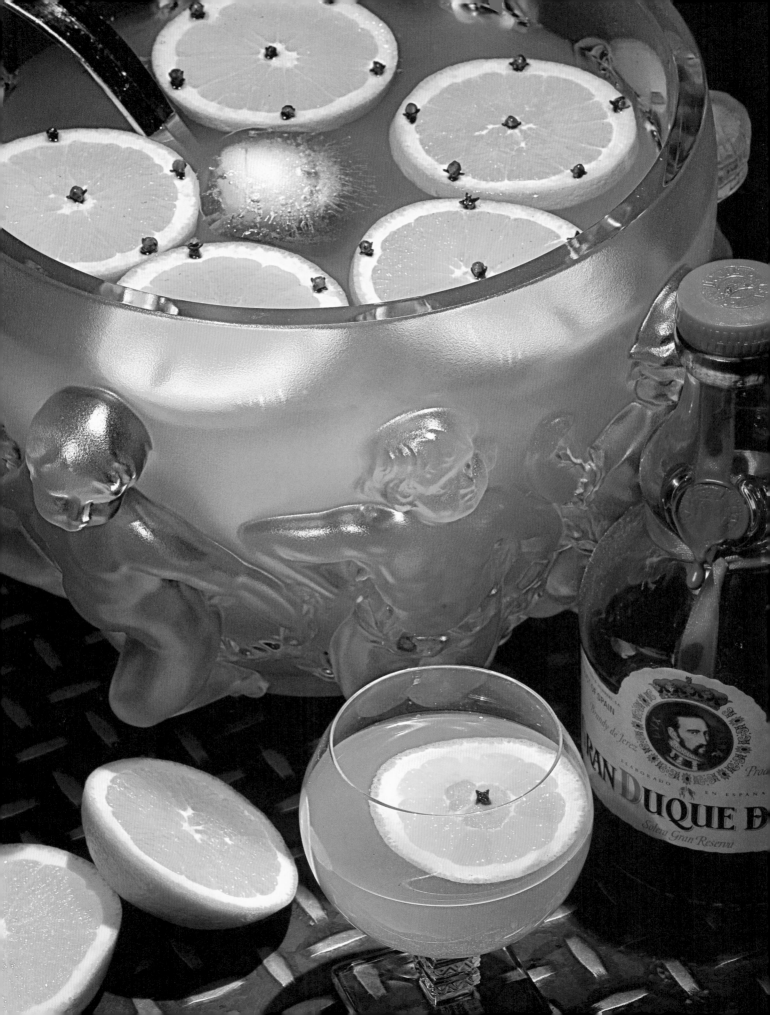

LE JARDIN VERT

BASE SPIRIT: Lime Vodka // MODIFIERS: Junmai Daijingo Sake & Prosecco

1 oz. FRESH ENGLISH-
CUCUMBER JUICE
(SKINS ON)

1/2 oz. CANE-SUGAR
SIMPLE SYRUP

1/4 oz. FRESH YUZU JUICE

3/4 oz. HANGAR ONE
KAFFIR-LIME VODKA

1 oz. SATO NO
HATTARI SAKE

1/2 oz. PROSECCO

GARNISH: EDIBLE ROSEBUDS OR MICROFLOWERS

PLACE ALL INGREDIENTS EXCEPT PROSECCO
IN A MIXING GLASS. ADD LARGE ICE CUBES
AND SHAKE VIGOROUSLY. ADD PROSECCO
AND TUMBLE ROLL BACK AND FORTH 1 TIME.
TASTE FOR BALANCE. DOUBLE-STRAIN INTO A FLUTE.
GARNISH AND SERVE.

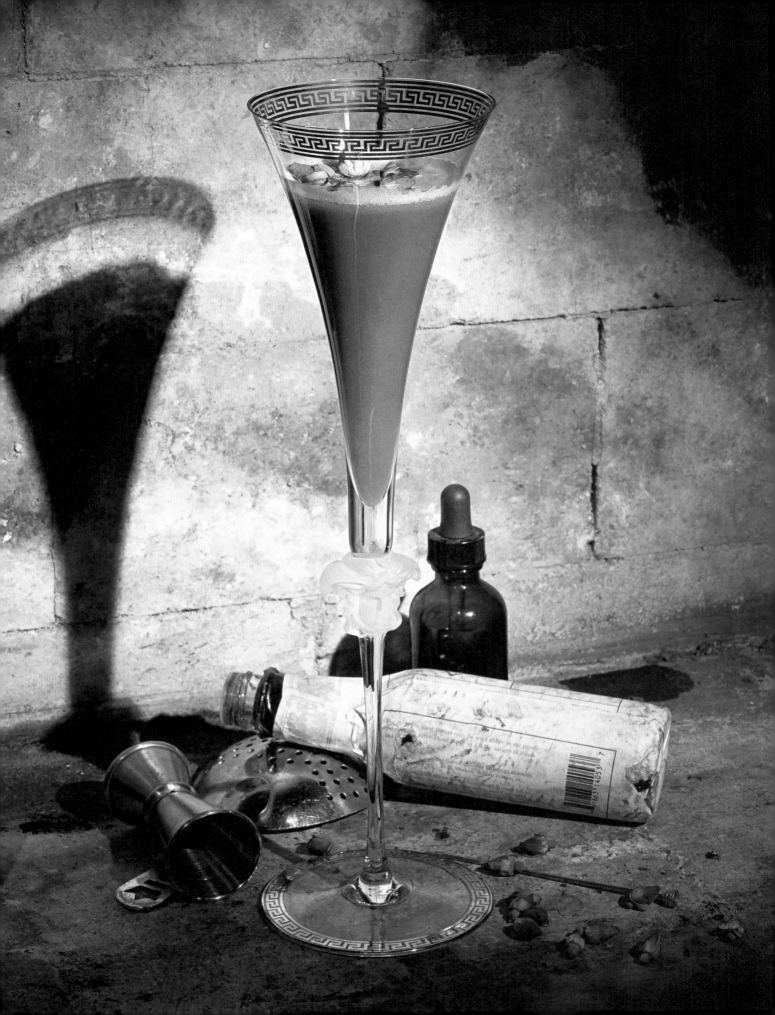

GYPSY WEDDING

BASE SPIRIT: Gin // MODIFIERS: Aquavit & Velvet Falernum

6 GREEN GRAPES

1/2 OZ. ACACIA-HONEY SYRUP 2:1

1/2 OZ. GRAPEFRUIT JUICE

3/4 OZ. FRESH LIME JUICE

1/4 OZ. JOHN D. TAYLOR'S VELVET FALERNUM

1/2 OZ. KROGSTAD AQUAVIT

1 1/2 OZ. BOMBAY DRY GIN

GARNISH: TOASTED FENNEL-SALT RIM

RIM A COUPE. PLACE ALL INGREDIENTS IN A MIXING GLASS. ADD LARGE ICE CUBES AND SHAKE VIGOROUSLY. TASTE FOR BALANCE - DOUBLE-STRAIN INTO A MARTINI GLASS. SERVE.

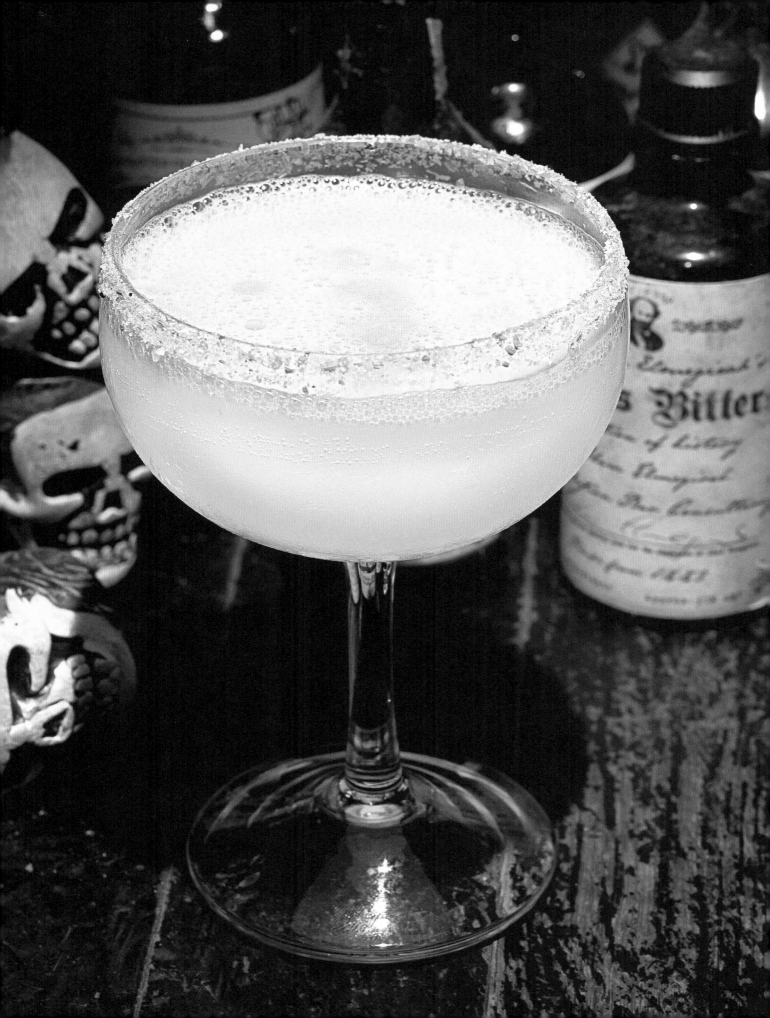

FRENCH LAUNDERED RED RUBIES

BASE SPIRIT: Grapefruit Vodka // MODIFIERS: Elderflower Liqueur & Yellow Chartreuse

1 oz. FRESH RUBY RED GRAPEFRUIT JUICE

1/4 oz. St. GERMAIN ELDERFLOWER LIQUEUR.

1/4 oz. YELLOW CHARTREUSE

1/2 oz. CANE-SUGAR SIMPLE SYRUP

1 oz. CHARBAY RUBY RED GRAPEFRUIT VODKA

1 DASH FEE BROTHERS GRAPEFRUIT BITTERS

1 oz. GUS STAR RUBY GRAPEFRUIT SODA

GARNISH: GRAPEFRUIT WEDGE

PLACE ALL INGREDIENTS EXCEPT SODA IN A MIXING GLASS. ADD LARGE ICE CUBES AND SHAKE VIGOROUSLY. ADD SODA AND TUMBLE ROLL BACK AND FORTH 1 TIME. TASTE FOR BALANCE. DOUBLE. STRAIN INTO A FLUTE OVER FRESH ICE, GARNISH, AND SERVE.

This cocktail is a tribute to The French Laundry restaurant, located in Yountville, California, and is made with Charbay vodka, manufactured in St. Helena, California.

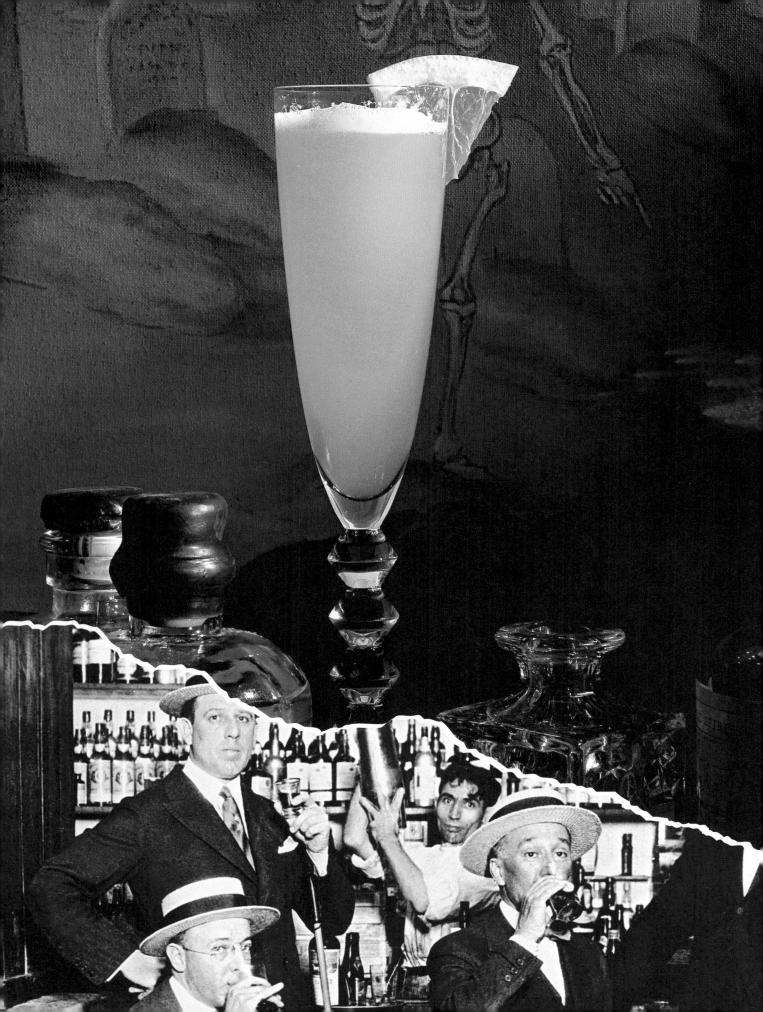

BLUEBERRY BLAZER

BASE SPIRIT: Overproof Whiskey // MODIFIERS: Amaretto & Grand Marnier 100

3 oz. HOT WATER
2 tsp. FRESH LEMON JUICE
2 tsp. ACACIA-HONEY SYRUP
1/2 oz. GRAND MARNIER CUVÉE DU CENTENAIRE (GM 100)
1/2 oz. LUXARDO AMARETTO DI SASCHIRA
1/2 oz. WHISTLEPIG OVER-PROOF RYE WHISKEY (OR BOOKER'S BOURBON)
1 WHOLE CLOVE STAR ANISE
GARNISH: LEMON WEDGE

FILL A WATER GLASS (OF SNIFTER) WITH HOT WATER, LEMON JUICE, AND HONEY SYRUP; STIR. PLACE ALL ALCOHOLIC INGREDIENTS AND STAR ANISE INTO A LIQUEUR GLASS AND IGNITE. ROTATE THE LIQUEUR GLASS FOR 10 SECONDS TO REDUCE ETHANOL AND CARAMELIZE WHISKEY. FROM A HEIGHT OF 10 INCHES, POUR CONTENTS OF LIQUEUR GLASS INTO SNIFTER. THIS SHOULD PRODUCE A BLUE FLAME AS YOU TRANSFER THE LIQUID.

* IF THERE IS STILL A FLAME IN THE GLASS, EXTINGUISH BY PLACING A COCKTAIL NAPKIN OVER THE GLASS. TASTE FOR BALANCE, GARNISH, AND SERVE.

NOTE: Before igniting alcohol, you should practice the pouring technique with water until you are proficient pouring from 1 vessel to the other without spilling. Working with flaming alcohol is dangerous; take appropriate precautions.

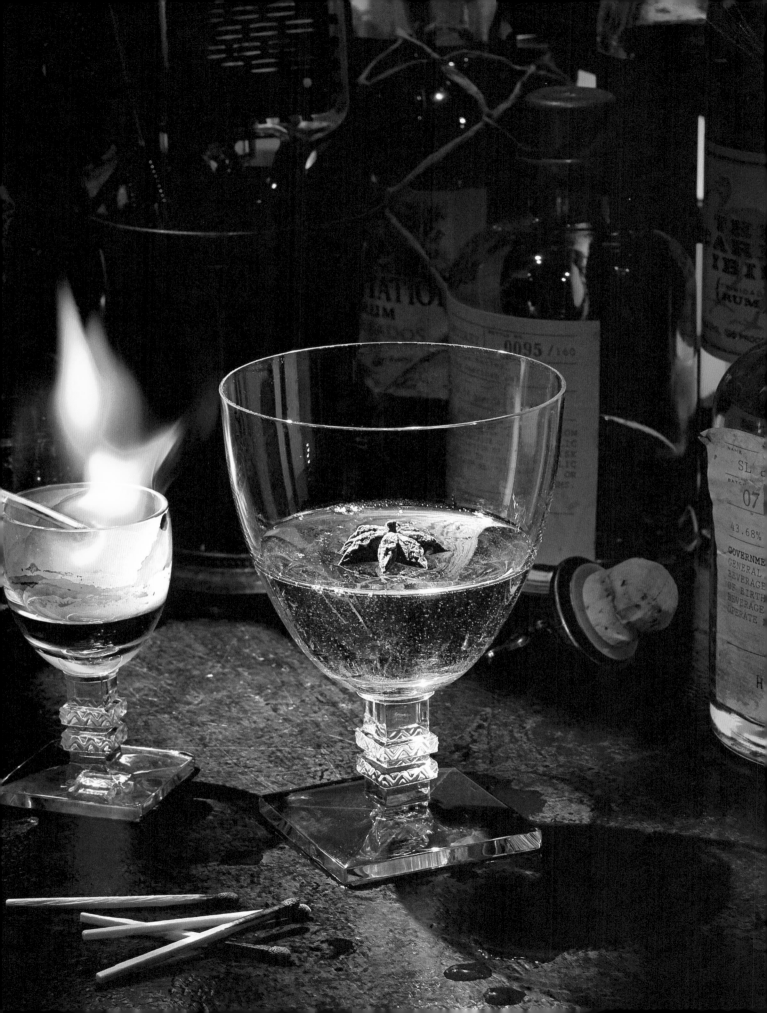

FLEUR DE LIS

BASE SPIRIT: Rye Whiskey // MODIFIER: Madeira

1 1/2 oz. MANGO PUREE

1/4 oz. FRESH LIME JUICE

1/2 oz. DEMERARA-SUGAR SYRUP

1/16 tsp. SMOKED CHIPOTLE CHILI POWDER

4 DASHES TABASCO CHIPOTLE CHILI SAUCE

1/2 oz. COSSART GORDON 10-YEAR BUAL MADEIRA

3 SPRIGS FRESH CILANTRO

1 1/4 oz. BULLEIT RYE WHISKEY

GARNISH: CILANTRO SPRIG WITH STIR STICK

PLACE ALL INGREDIENTS EXCEPT RYE WHISKEY IN A MIXING GLASS. MUDDLE CILANTRO, THEN ADD RYE WHISKEY. ADD LARGE ICE CUBES AND SHAKE VIGOROUSLY. TASTE FOR BALANCE. DOUBLE-STRAIN INTO A GLASS, GARNISH, AND SERVE.

This cocktail was created shortly after Hurricane Katrina ravaged the city of New Orleans; the James Beard Foundation wanted to help raise money for victims during a charity dinner. This drink includes ingredients sourced from Louisiana, most notably Tabasco hot sauce, which is produced by the McIlhenny Company.

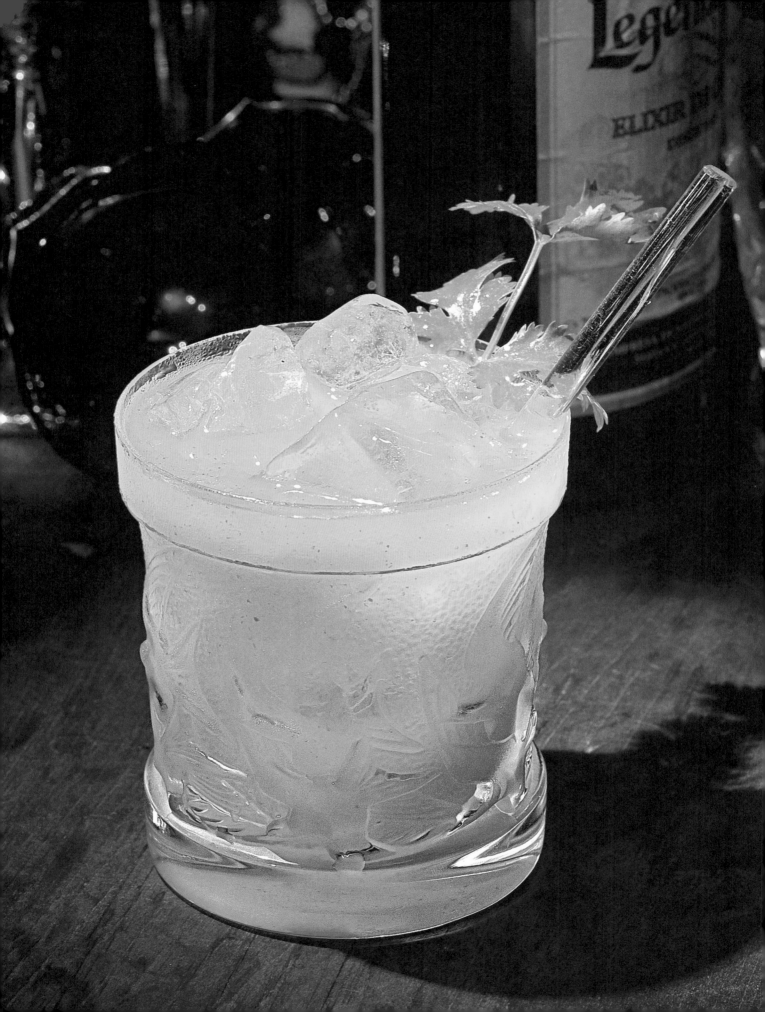

ZEST (DUTCHMAN'S GOLD)

BASE SPIRIT: XO Cognac // MODIFIERS: Dry Palo Cortado Sherry & Gin

1/4 OZ. FRESH LEMON JUICE 1/2 OZ. CANE-SUGAR SIMPLE SYRUP 1 1/2 OZ. LUSTAU ALMACENISTA PALO CORTADO DRY SHERRY 3/4 OZ. FRAPIN CHATEAU DE FONTPINOT XO COGNAC 1/4 OZ. BOLS DAMRAK GIN OR BOLS GENEVIEVE GENEVER 1 DASH ANGOSTURA BITTERS 3/4 OZ. GUS DRY MEYER LEMON SODA

PLACE ALL INGREDIENTS EXCEPT SODA IN A MIXING TIN. ADD LARGE ICE CUBES AND SHAKE VIGOROUSLY; DOUBLE-STRAIN INTO A COUPE. ADD SODA AND TUMBLE ROLL BACK AND FORTH 1 TIME. TASTE FOR BALANCE, GARNISH, AND SERVE.

GARNISH: FLAMED LEMON ZEST

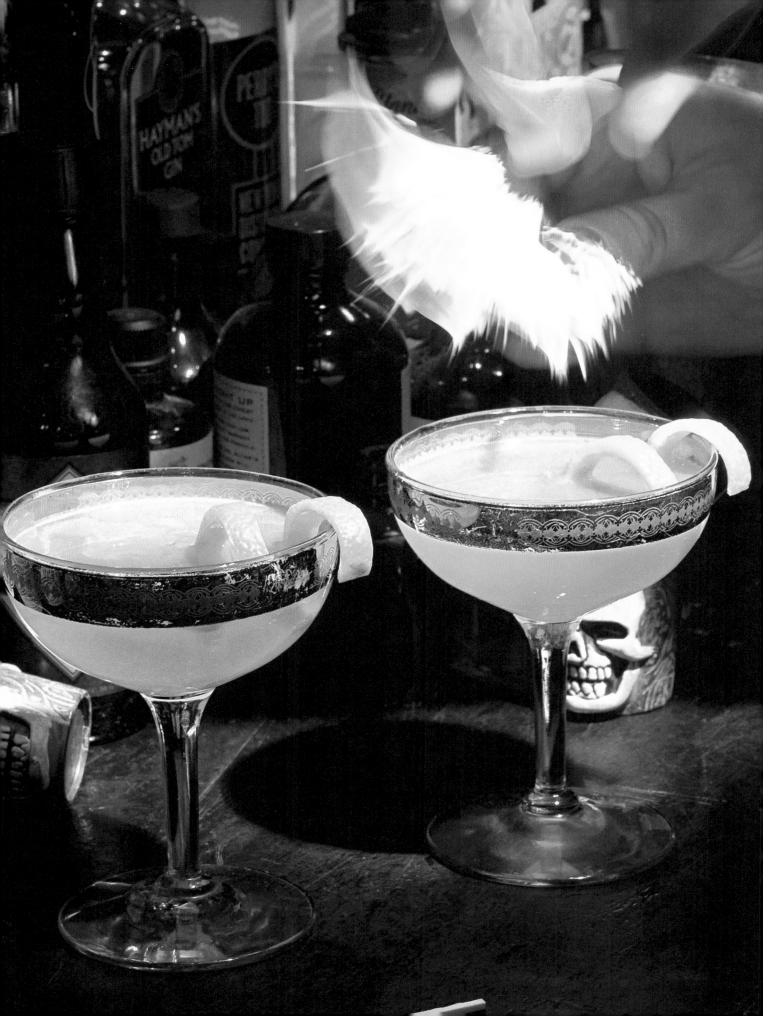

PUMPKIN PIE

BASE SPIRIT: Aged Rum // MODIFIER: Orgeat Liqueur

1 1/2 oz. PUMPKIN PUREE (with 1/4 tsp. of freshly ground cinnamon and allspice)

1 1/2 oz. HALF-AND-HALF

1/2 oz. CANE-SUGAR SIMPLE SYRUP

1/2 oz. APPLETON ESTATE GRAND RESERVE RUM

1/16 oz. ORGEAT SYRUP OR LIQUEUR

GARNISH: STEAMED HALF-AND-HALF FOAM & FRESHLY GROUND NUTMEG DUSTED ON TOP

PLACE ALL INGREDIENTS IN A MIXING TIN. STEAM UNTIL LIQUID IS HOT, WITH A NICE TEXTURED FOAM. TASTE FOR BALANCE. SINGLE-STRAIN INTO A DEMITASSE. USE A BAR SPOON TO LADLE FOAM ON TOP, GARNISH WITH NUTMEG, AND SERVE.

NOTE: This drink can also be served as a nonalcoholic cold float in a highball glass with a scoop of vanilla or pumpkin ice cream.

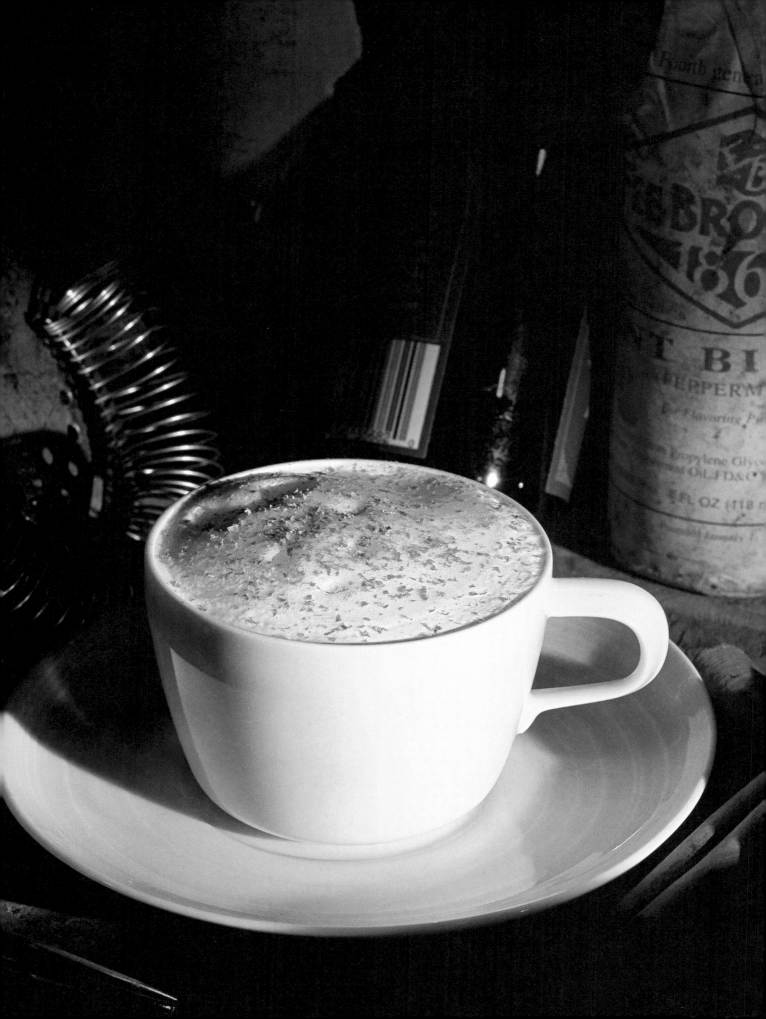

THE BAREFOOT CONTESSA

BASE SPIRIT: Tequila // MODIFIER: Palo Cortado Sherry

1/2 oz. FRESH LIME JUICE

1/2 oz. AGAVE NECTAR

1 oz. MANGO PUREE

1 SPRIG ROSEMARY LEAVES

1.1/2 oz. DON JULIO AÑEJO TEQUILA

1/4 tsp. CHIPOTLE-CHILE POWDER

1/2 oz. LUSTAU ALMACENISTA PALO CORTADO DRY SHERRY

GARNISH: 1 SPRIG ROSEMARY

PLACE ALL INGREDIENTS EXCEPT TEQUILA AND SHERRY IN A MIXING GLASS. LIGHTLY MUDDLE ROSEMARY. ADD TEQUILA AND SHERRY. DRY-SHAKE TO EMULSIFY CHILE POWDER. ADD LARGE ICE CUBES AND SHAKE AGAIN. TASTE FOR BALANCE. DOUBLE-STRAIN INTO A COUPE, GARNISH, AND SERVE.

I created this cocktail as a guest on the Food Network's *Barefoot Contessa*, starring Ina Garten. She wanted something to pair with a chipotle, rosemary, and mixed nuts recipe.

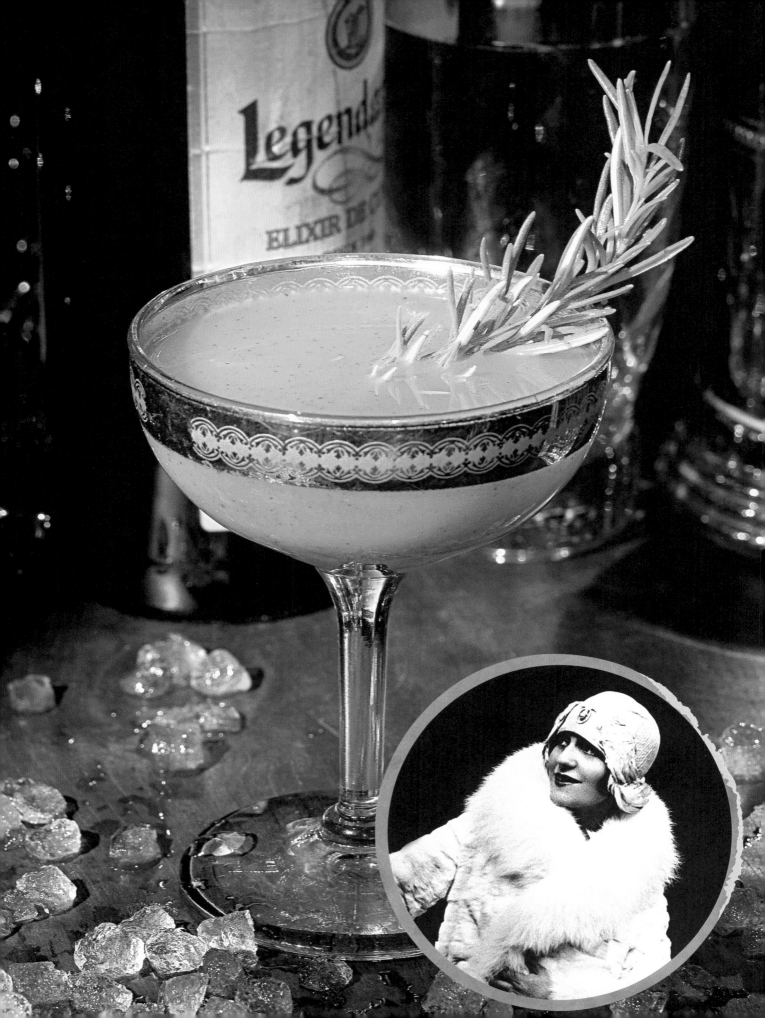

D-DAY SPOILS

BASE SPIRIT: Calvados // MODIFIER: Pommeau de Normandie

1 OZ. NONALCOHOLIC MACINTOSH APPLE CIDER

½ OZ. DEMERARA-SUGAR SYRUP

1¼ OZ. FRESH LIME JUICE

½ OZ. POMMEAU DE NORMANDIE

1½ OZ. ADRIEN CAMUS 18-YEAR PRIVILEGE CALVADOS PAYS D'AUGE

1¼ OZ. DUCHE DE LONGUEVILLE NONALCOHOLIC SPARKLING CIDER

GARNISH: GREEN & RED APPLE SLIVERS

PLACE ALL INGREDIENTS EXCEPT SPARKLING CIDER IN A MIXING TIN. ADD LARGE ICE CUBES AND SHAKE VIGOROUSLY. ADD SPARKLING CIDER AND TUMBLE ROLL BACK AND FORTH 1 TIME. TASTE FOR BALANCE. DOUBLE-STRAIN INTO A FLUTE. GARNISH, AND SERVE.

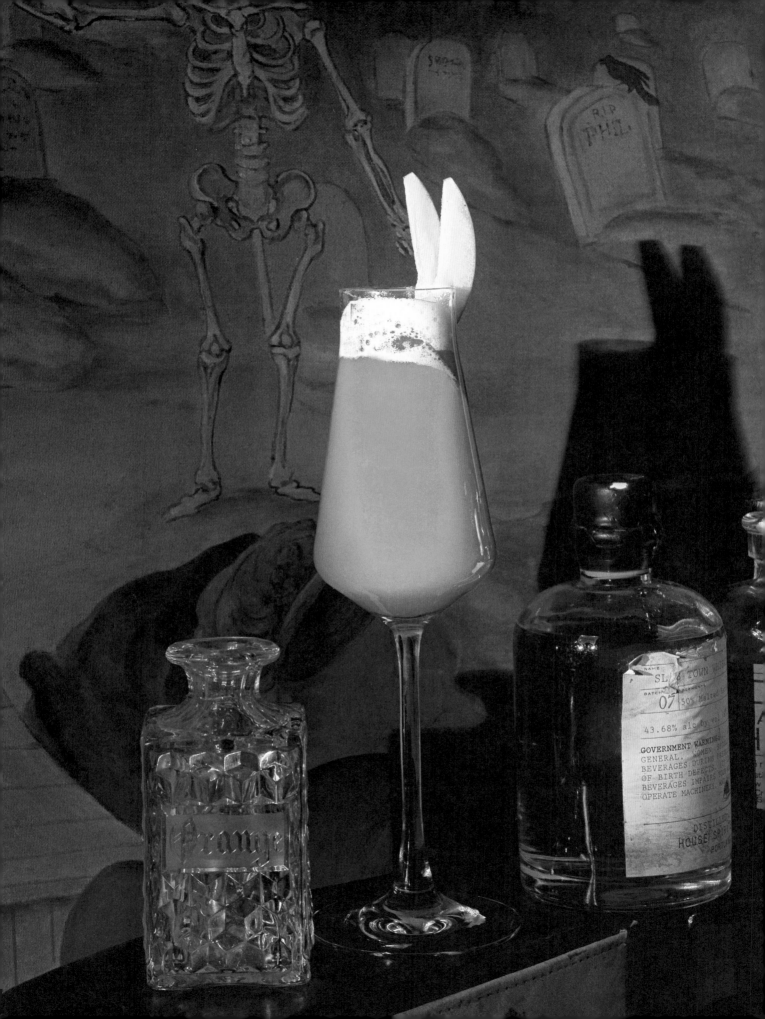

BLUE-CUMBER

BASE SPIRIT: Pisco // MODIFIERS: Blueberry Vodka & Moscato d'Asti

1/4 OZ. FRESH LIME JUICE

3/4 OZ. CANE-SUGAR SIMPLE SYRUP

1 OZ. JUICED CUCUMBER

1 1/4 OZ. BARSOL ACHOLADO PISCO

1/4 OZ. STOLI BLUEBERI VODKA

1/2 OZ. SARACCO MOSCATO D'ASTI

GARNISH: SKEWERED CUCUMBER RIBBON WITH 3 BLUEBERRIES

PLACE ALL INGREDIENTS EXCEPT MOSCATO D'ASTI
IN A COCKTAIL TIN.
ADD LARGE ICE CUBES AND SHAKE VIGOROUSLY.
ADD MOSCATO D'ASTI, THEN TUMBLE ROLL
BACK AND FORTH ONCE. TASTE FOR BALANCE.
DOUBLE-STRAIN,
GARNISH, AND SERVE.

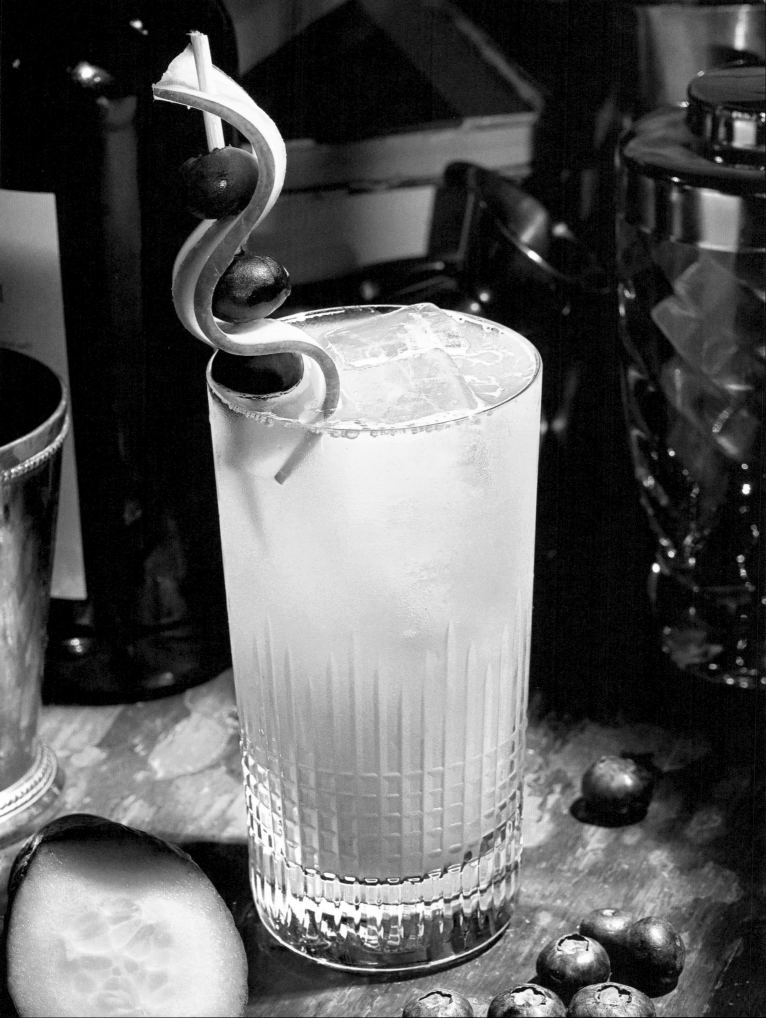

THE WRATH OF GRAPES

BASE SPIRITS: Pisco & Grape Vodka
MODIFIERS: Pineau des Charentes & Grand Marnier 100

1/2 OZ. WHITE GRAPE JUICE

1 1/2 OZ. PINEAU DES CHARENTES

1/2 OZ. GRAND MARNIER CUVÉE DU CENTENAIRE (GM 100)

1/2 OZ. CÎROC VODKA

1/2 OZ. BARSOL PISCO MOSTO VERDE QUEBRANTA

PLACE ALL INGREDIENTS IN A GLASS. ADD LARGE ICE CUBE AND STIR WELL. TASTE FOR BALANCE.

STRAIN INTO A COUPE, GARNISH, AND SERVE.

GARNISH: SMALL CLUSTER OF FROZEN SEEDLESS RED GRAPES

Every component of this drink is made from grapes. Mixologists tend to shy away from vodka in lieu of spirits with more flavor. Grape-based vodkas, however, are essentially filtered eaux-de-vie and therefore offer more.

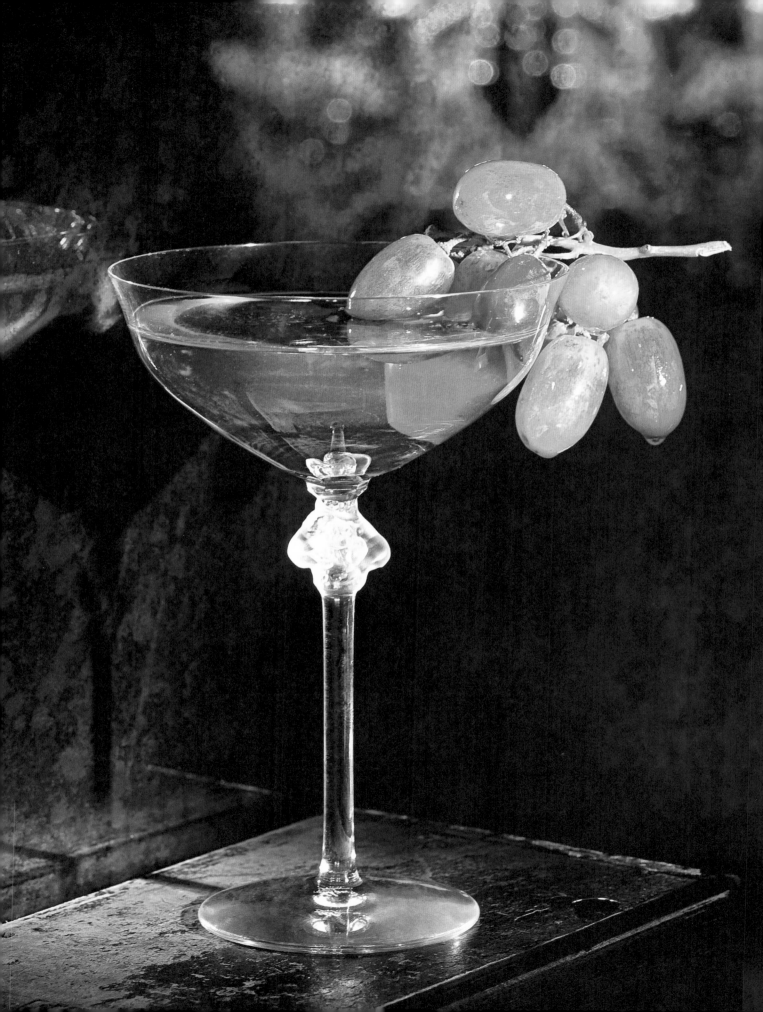

STUCK IN A JAM

BASE SPIRIT: White Whiskey // MODIFIER: Dimmi Liqueur

1 STRAWBERRY

1 2-INCH CUBE WATERMELON

1 SPRIG LAVENDER

3/4 OZ. FRESH LIME JUICE

1 1/4 OZ. CANE-SUGAR SIMPLE SYRUP

1 OZ. HUDSON NEW YORK CORN WHISKEY

1/4 OZ. DIMMI LIQUORE DI MILANO

1/4 OZ. SPARKLING WATER

GARNISH: LAVENDER SPRIG

PLACE STRAWBERRY AND WATERMELON IN A MIXING GLASS, GENTLY MUDDLE. PLACE REMAINING INGREDIENTS IN THE MIXING GLASS. ADD LARGE ICE CUBES AND SHAKE VIGOROUSLY. TASTE FOR BALANCE. POUR CONTENTS DIRECTLY INTO A JAM JAR, GARNISH, AND SERVE ON THE LID (AS A COASTER).

92

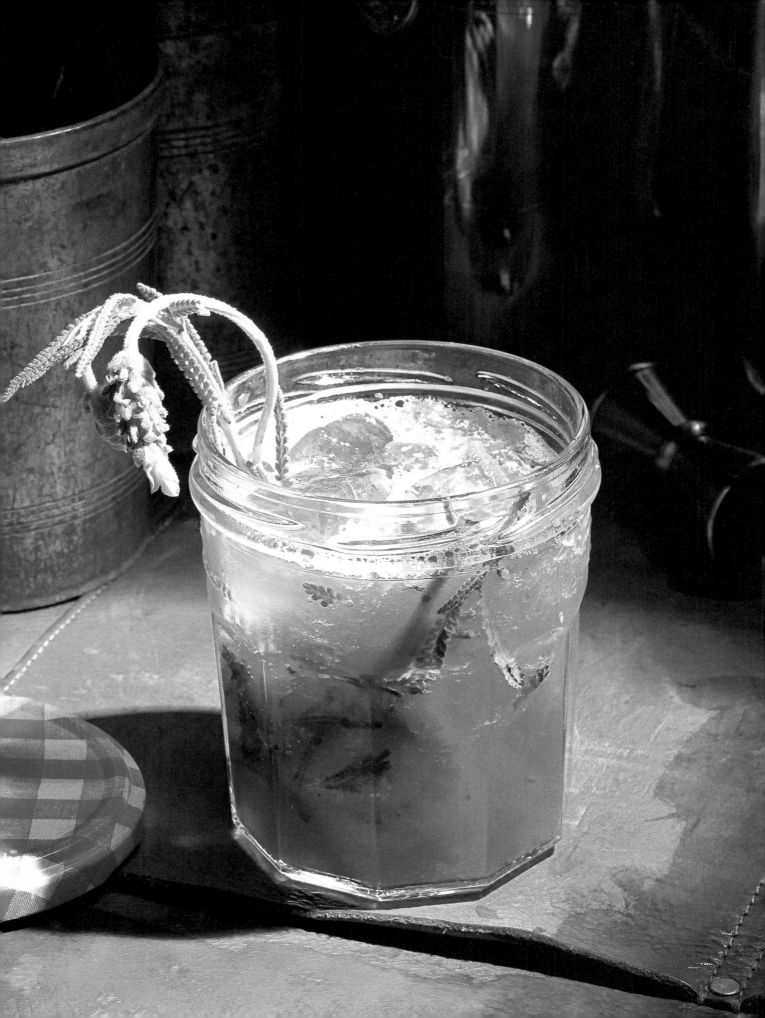

DON JULIO'S DELIGHT

BASE SPIRIT: Añejo Tequila // MODIFIERS: Bourbon & Amaretto

1/4 OZ. FRESH LIME JUICE

1 1/4 OZ. AGAVE NECTAR

1/16. OZ. LUXARDO AMARETTO DI SASCHIRA

1/4 OZ. FOUR ROSES BOURBON
(sub: BULLEIT BOURBON)

1 1/4 OZ. DON JULIO 1942 TEQUILA

1 EGG WHITE GARNISH: LIME WEDGE

PLACE ALL INGREDIENTS IN A MIXING GLASS. DRY-SHAKE
WITH A HAWTHORNE COIL STRAINER. ADD LARGE
ICE CUBES AND SHAKE VIGOROUSLY. TASTE FOR BALANCE.
SINGLE-STRAIN INTO A GLASS, GARNISH, AND SERVE.

This drink is dedicated to the late Don Julio González-Frausto Estrada, founder of Don Julio's Tequila.

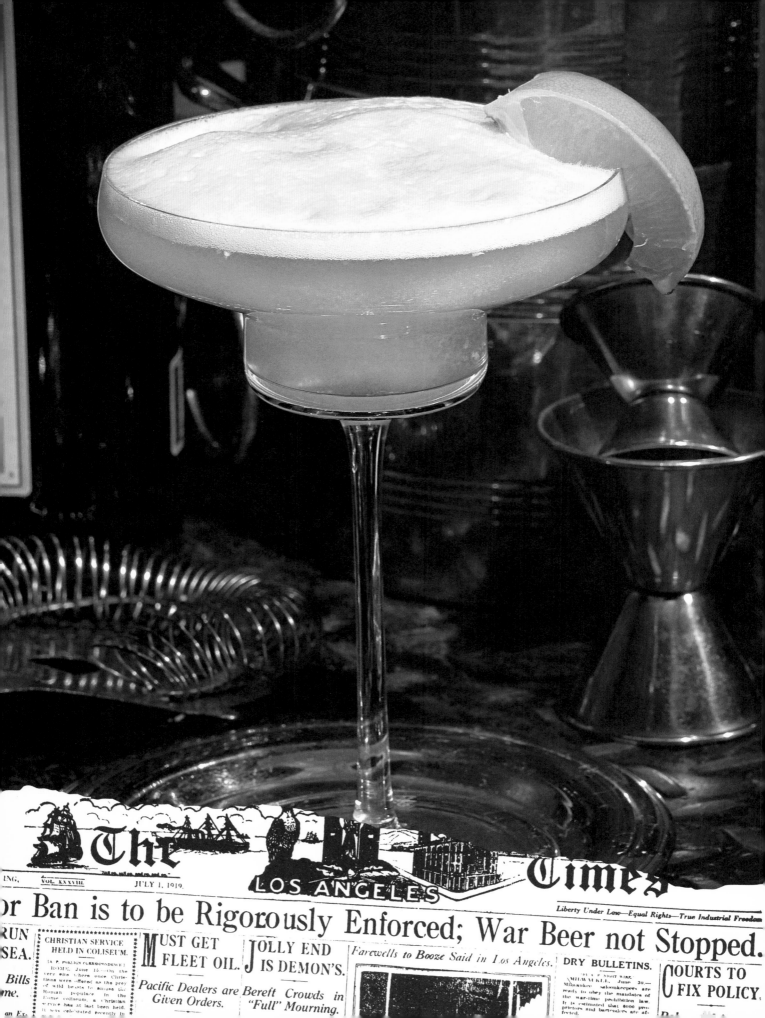

CUZCO

BASE SPIRIT: Pisco // MODIFIERS: Aperol & Kirschwasser

KIRSCHWASSER

3/4 oz. CANE-SUGAR SIMPLE SYRUP

1/2 oz FRESH LEMON JUICE

1/2 oz. GRAPEFRUIT JUICE

3/4 oz. APEROL

2 oz. BARSOL PISCO SUPREMO MOSTO VERDE

GARNISH: GRAPEFRUIT TWIST

RINSE GLASS WITH KIRSCHWASSER. PLACE ALL OTHER INGREDIENTS IN A MIXING TIN. ADD LARGE ICE CUBES AND SHAKE VIGOROUSLY. TASTE FOR BALANCE. DOUBLE-STRAIN INTO A HIGHBALL OVER FRESH ICE, GARNISH, AND SERVE.

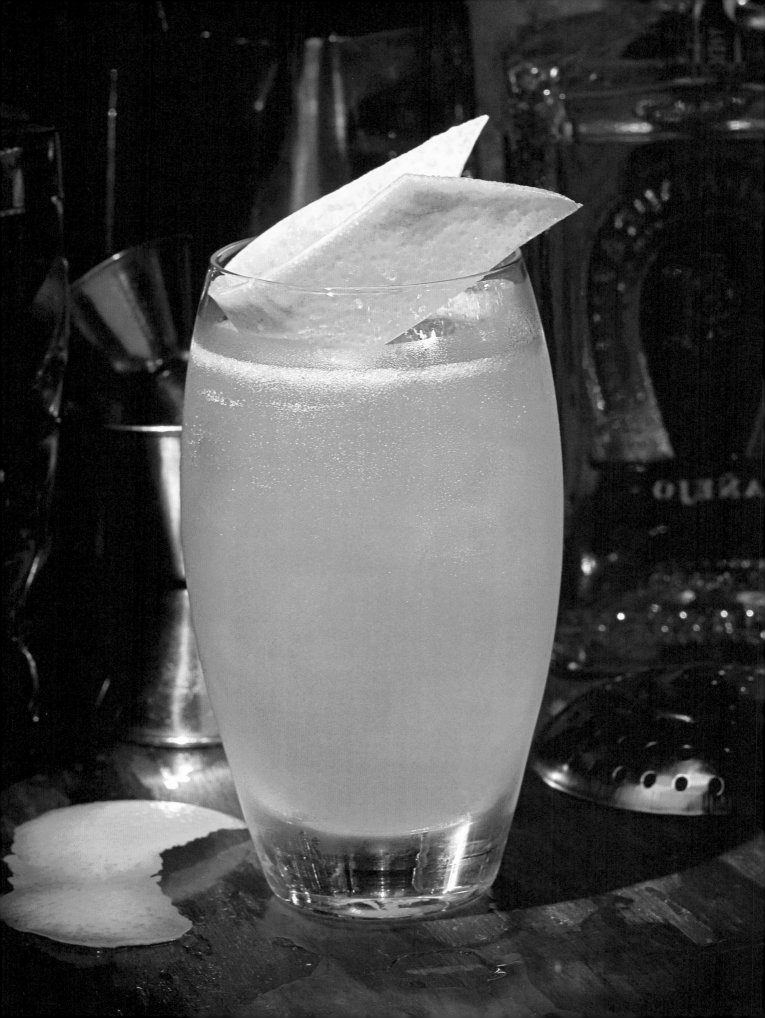

BLACK CHERRY BITTERED SLING

BASE SPIRIT: Single Barrel Bourbon

3/4 OZ. CANE-SUGAR SIMPLE SYRUP

3/4 OZ. FRESH LIME JUICE

1 1/2 OZ. BLANTON'S ORIGINAL SINGLE BARREL BOURBON (OR FOUR ROSES SINGLE BARREL BOURBON)

3 DASHES
FEE BROTHERS CHERRY BITTERS

1 OZ. DRIED CHERRY JUICE AND CLUB SODA
(OR BOYLAN BLACK CHERRY SODA)

GARNISH:
GROUND NUTMEG & 3 DRIED CHERRIES, REHYDRATED AND SKEWERED

PLACE FIRST 4 INGREDIENTS IN A MIXING TIN. ADD LARGE ICE CUBES AND SHAKE VIGOROUSLY. DOUBLE-STRAIN INTO A TUMBLER OVER FRESH ICE, THEN ADD CARBONATED COMPONENT. TUMBLE ROLL BACK AND FORTH ONCE AND TASTE FOR BALANCE. GARNISH AND SERVE.

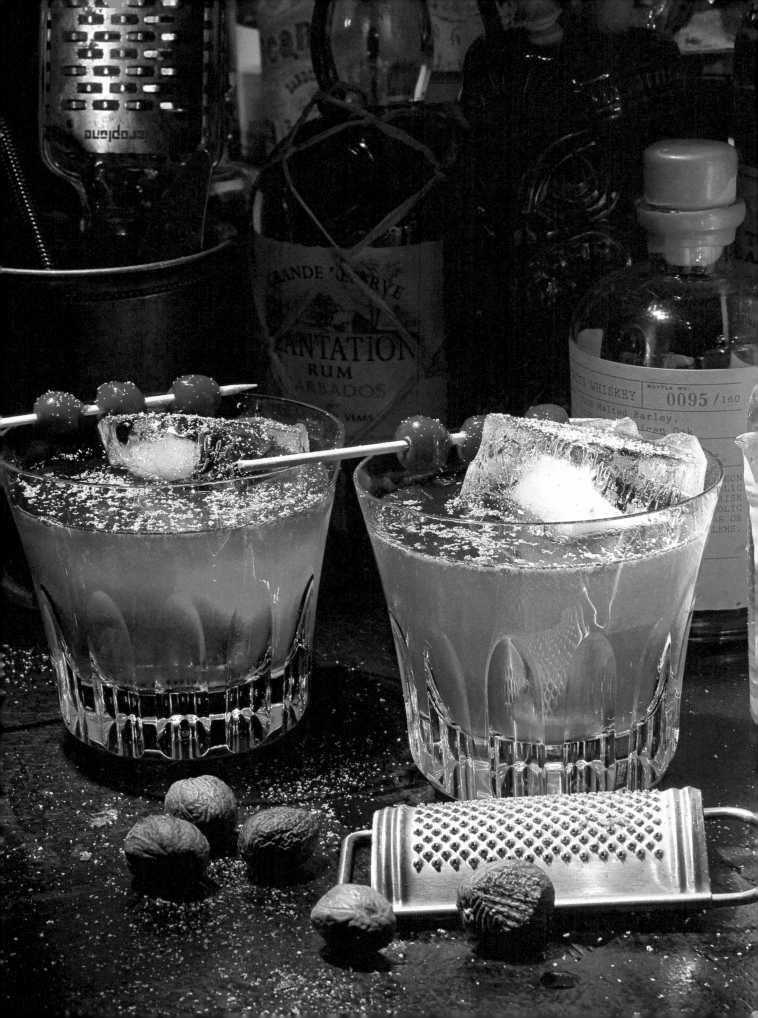

GIN BLOSSOM

BASE SPIRIT: Gin // MODIFIERS: Vermouth & Apricot Eau-de-Vie

2 DASHES ANGOSTORA ORANGE BITTERS

3/4 OZ. APRICOT EAU-DE-VIE

1 1/2 OZ. MARTINI BLANCO VERMOUTH

1 1/2 OZ. PLYMOUTH GIN

GARNISH: ORANGE TWIST

PLACE ALL INGREDIENTS IN A MIXING GLASS. ADD LARGE ICE CUBES AND STIR THOROUGHLY. TASTE FOR BALANCE, SINGLE-STRAIN INTO A MARTINI GLASS, TAKING CARE NOT TO AERATE. SERVE

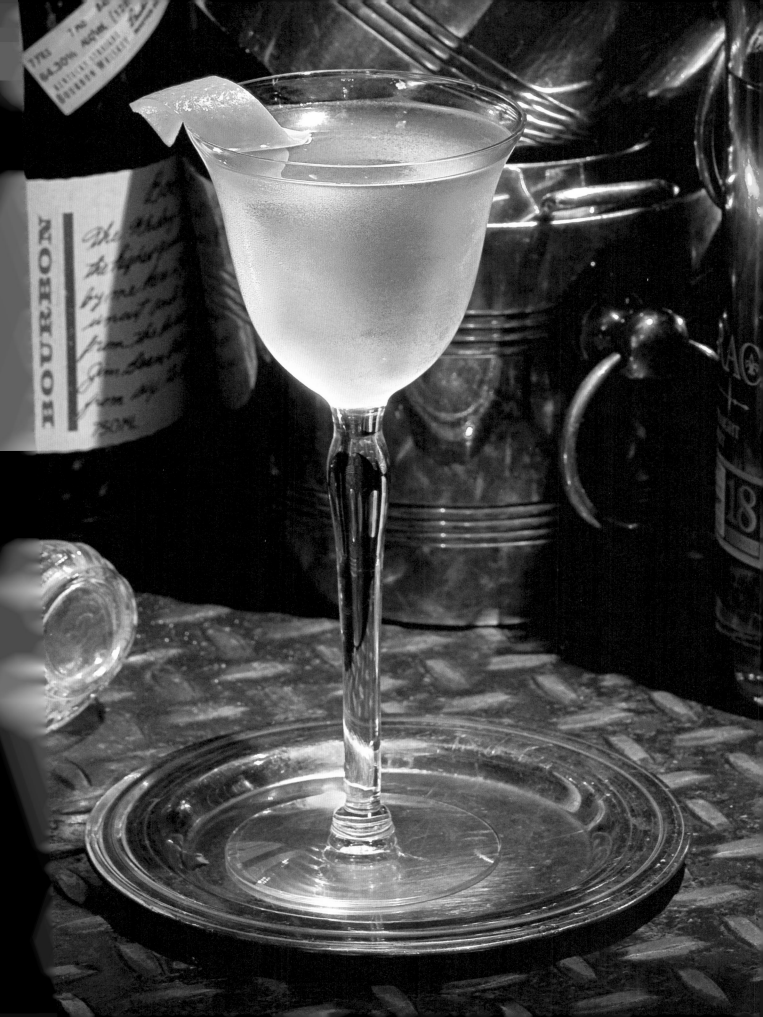

BENTON'S OLD FASHIONED

BASE SPIRIT: Bacon-Infused Bourbon

2 DASHES ANGOSTURA BITTERS

1/4 OZ. DEEP MOUNTAIN GRADE B MAPLE SYRUP

2 OZ. BENTON'S BACON-INFUSED FOUR ROSES BOURBON (SEE BELOW)

GARNISH: ORANGE TWIST

BENTON'S BACON INFUSION:

1½ oz. fat from Benton's Hickory Smoked Country bacon
750 ml. bottle Four Roses bourbon

Warm the bacon fat in a small saucepan over low heat. Stir until it melts, about 5 minutes. Pour the liquid fat into a large nonreactive container. Add the bourbon and stir. Cover and let stand for 4 hours. Then place the container in a freezer for 2 hours. Remove the solid fat and strain through a terry cloth or cheesecloth. Return the result to the original bottle and label it.

Yield: 24 oz.

PLACE ALL INGREDIENTS IN A MIXING GLASS. ADD LARGE ICE CUBES AND STIR THOROUGHLY. TASTE FOR BALANCE. ADD A LARGE CUBE TO A CHILLED OLD-FASHIONED GLASS. SLOWLY POUR FROM MIXING GLASS, TAKING CARE NOT TO AERATE. GARNISH AND SERVE.

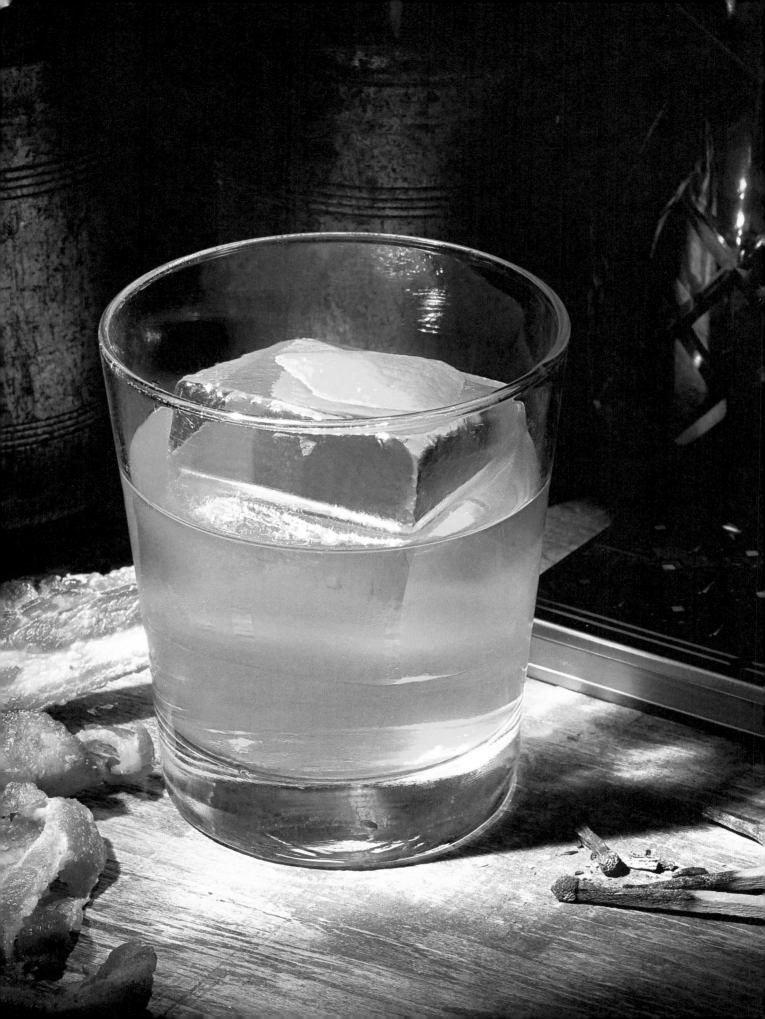

THE TIFFANY & CO. COCKTAIL

BASE SPIRIT: Pear Vodka // MODIFIERS: Alizé Bleu Liqueur & Moscato d'Asti

1/2 oz. FRESH LIME JUICE

1/2 oz. CANE-SUGAR SIMPLE SYRUP

1/2 oz. GREY GOOSE PEAR VODKA

4 oz. RUFFINO MOSCATO D'ASTI

1/4 to 1/2 oz. ALIZÉ BLEU COGNAC-VODKA LIQUEUR

GARNISH: WHITE RIBBON (OR WHITE BOW TIE)

ADD LIME JUICE, SIMPLE SYRUP, AND VODKA TO A CHAMPAGNE FLUTE. SLOWLY ADD MOSCATO D'ASTI UNTIL THE FOAM SUBSIDES WITHIN 1 INCH OF THE TOP. SLOWLY STIR IN ALIZÉ BLEU UNTIL THE PERFECT SHADE OF TIFFANY BLUE IS ACHIEVED.

In 2007, Tiffany & Co. approached me at the Bemelmans Bar at The Carlyle hotel and requested a special drink to launch its new line of cocktail rings. The difficulty came in trying to create a fresh blue cocktail exuding luxury. There are very few quality blue spirits and it is always best to avoid food coloring. The final result was not only tasty and elegant, but it came out the perfect shade of Tiffany blue.

BUTTERNUT-SQUASHED SIDECAR

BASE SPIRIT: Cognac
MODIFIER: Cointreau

¼ oz. FRESH LIME JUICE

½ oz. CANE-SUGAR SIMPLE SYRUP

1¼ oz. BUTTERNUT-SQUASH PUREE

¼ oz. COINTREAU

1½ oz. MARTELL CORDON BLEU COGNAC

3 DASHES DALE DEGROFF'S PIMENTO AROMATIC BITTERS

GARNISH: CONFECTIONER'S SUGAR RIM & FRESHLY GROUND NUTMEG ON TOP

OVEN ROAST BUTTERNUT SQUASH PUREE (NO SALT). PLACE ALL INGREDIENTS IN A MIXING GLASS. ADD LARGE ICE CUBES AND SHAKE VIGOROUSLY. TASTE FOR BALANCE. RIM A GLASS WITH SUGAR. DOUBLE-STRAIN, GARNISH WITH GROUND NUTMEG ON TOP, AND SERVE.

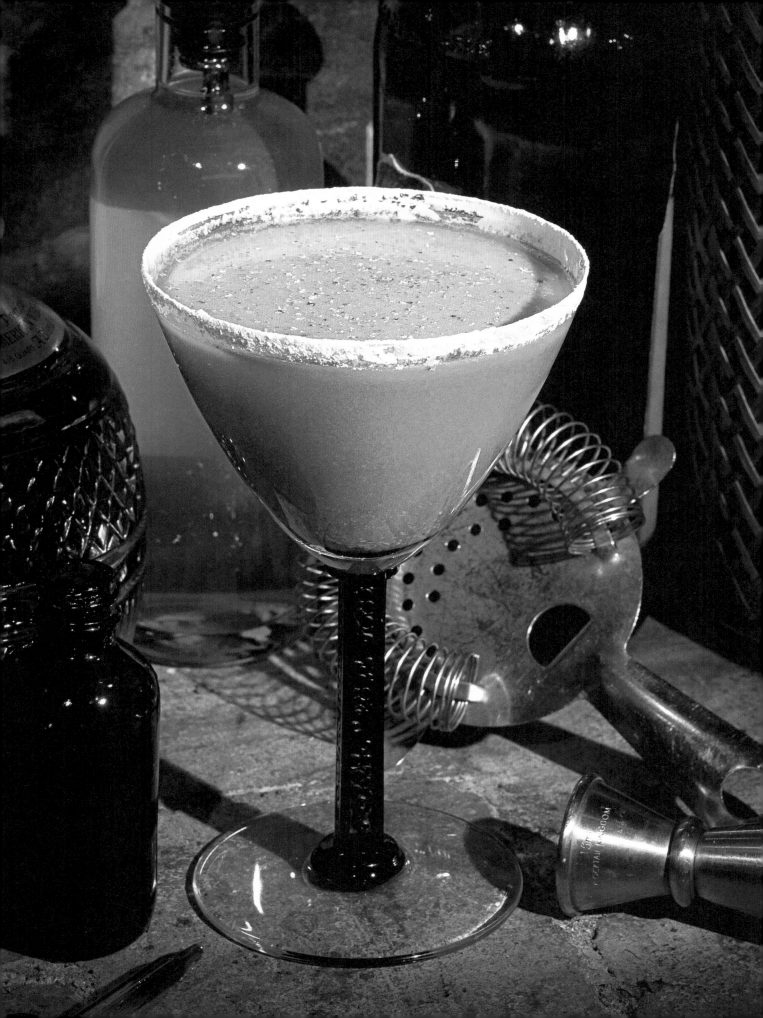

HOIST THE COLORS PUNCH

BASE SPIRITS: Aged & Dark Rum // MODIFIER: Overproof Rum

9 WHITE SUGAR CUBES

3 oz. CLUB SODA

3 oz. FRESH LEMON JUICE

4 1/2 oz. B.G. REYNOLDS' DON'S MIX

1 1/2 oz. FRESH PINEAPPLE JUICE

4 1/2 oz. APPLETON ESTATE V/X JAMAICAN RUM

3 oz. GOSLING'S BLACK SEAL BERMUDA BLACK RUM

1 1/2 oz. EL DORADO SUPERIOR HIGH STRENGTH 151-PROOF RUM

3 DASHES ANGOSTURA BITTERS

GARNISH: GROUND NUTMEG & 5 LEMON WHEELS

PLACE ALL INGREDIENTS IN A MIXING GLASS. ADD LARGE ICE CUBES AND STIR THOROUGHLY. TASTE FOR BALANCE. LADLE INTO PUNCH CUPS, GARNISH, AND SERVE.

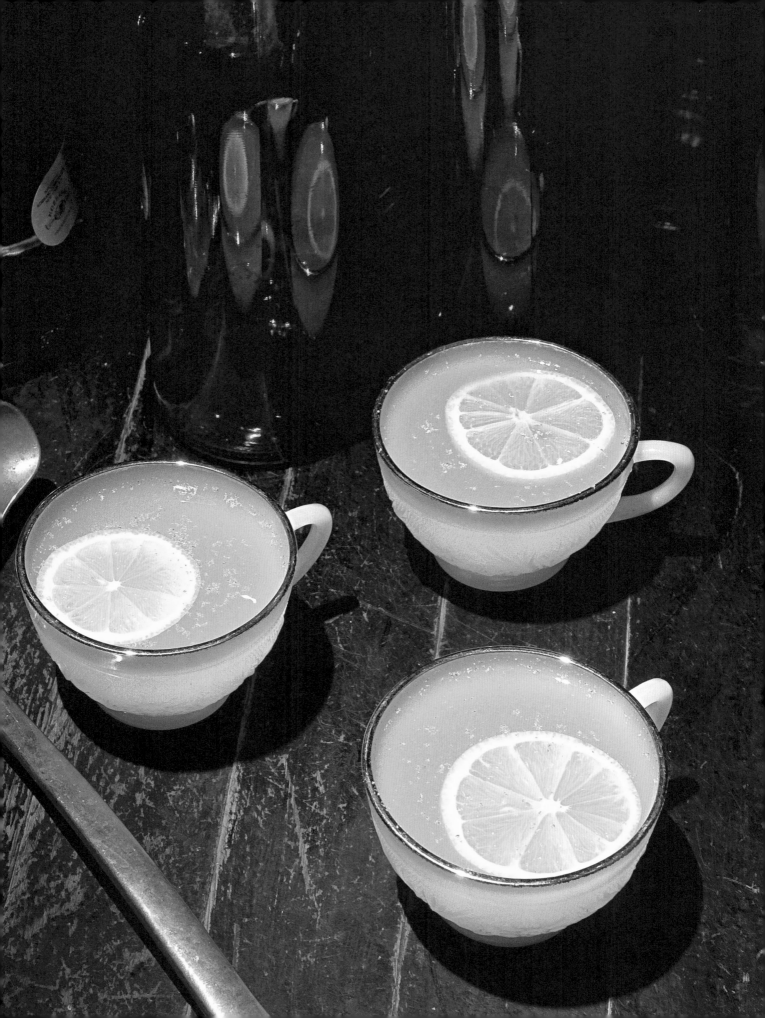

LA VIÑA

BASE SPIRIT: Rye Whiskey // MODIFIERS: Amaro & PX Sherry

1 DASH REGAN'S ORANGE BITTERS NO.6

1 oz. LUSTAU EAST INDIA SOLERA SHERRY

1 oz. AMARO NONINO

1 oz. RUSSELL'S RESERVE RYE WHISKEY

GARNISH: ORANGE TWIST

PLACE ALL INGREDIENTS IN A MIXING GLASS. ADD LARGE ICE CUBES AND STIR THOROUGHLY. TASTE FOR BALANCE. SINGLE-STRAIN INTO A MARTINI GLASS, TAKING CARE NOT TO AERATE.

GARNISH AND SERVE.

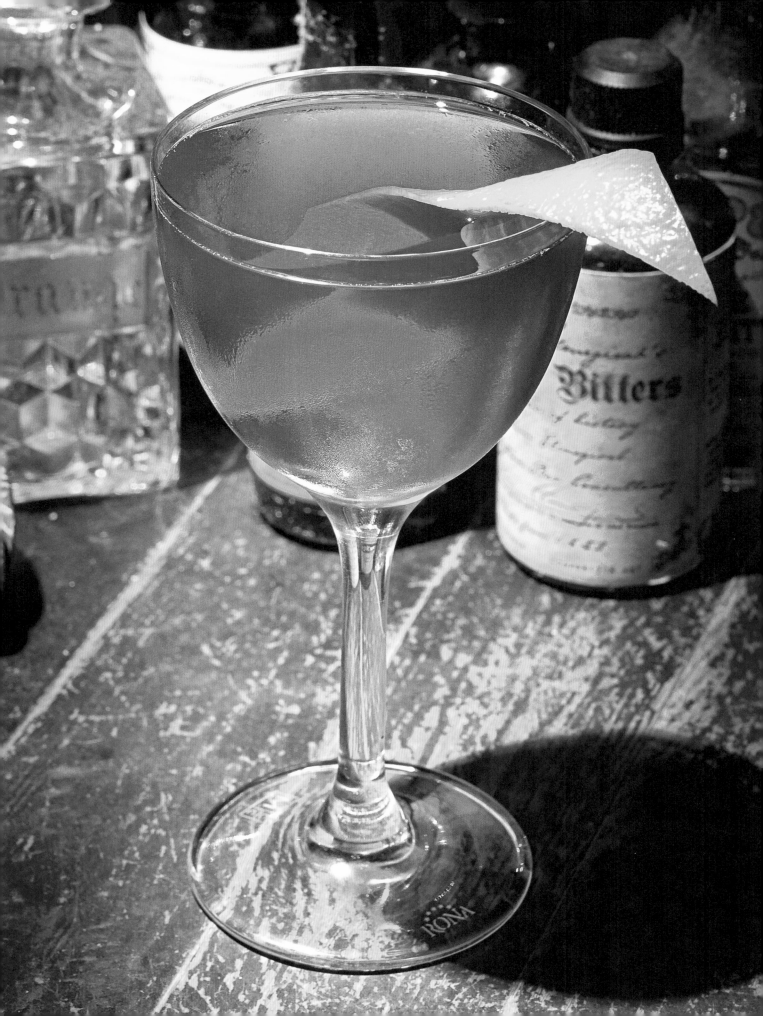

PEANUT BUTTER CUP

BASE SPIRIT: Bourbon // MODIFIER: PX Sherry

1/2 OZ. PEANUT BUTTER SYRUP (SEE BELOW)

3/4 OZ. CELERY JUICE

1/2 OZ. LUSTAU PEDRO XIMÉNEZ SHERRY

2 OZ. BULLEIT BOURBON

GARNISH:
CELERY STALK

PLACE ALL INGREDIENTS IN A MIXING TIN. ADD LARGE ICE CUBES AND SHAKE VIGOROUSLY. TASTE FOR BALANCE. DOUBLE-STRAIN INTO A GLASS OVER FRESH ICE. GARNISH AND SERVE.

PEANUT BUTTER SYRUP:
18 oz. peanut butter, 32 oz. clover honey, 2 cups hot water // Simmer mixture over medium-low heat in a deep sauce pan, stir frequently until all ingredients are fully incorporated. Yield: 56 oz.

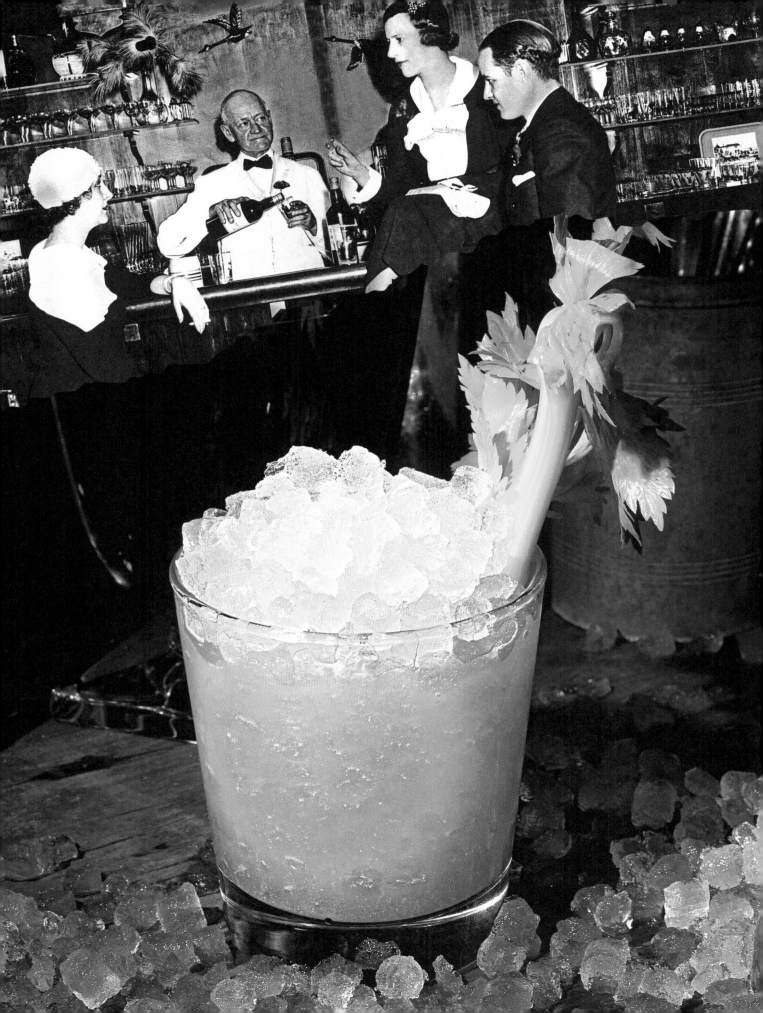

BILLIONAIRE COCKTAIL

BASE SPIRIT: Overproof Whiskey // MODIFIER: Absinthe Bitters

1/4 oz. ABSINTHE BITTERS

1/2 oz. EMPLOYEES ONLY GRENADINE

1/2 oz. RICH CANE-SUGAR SIMPLE SYRUP 2:1

1 oz. FRESH LEMON JUICE

2 oz. BAKER'S 7-YEAR 107-PROOF BOURBON

GARNISH: LEMON WHEEL

PLACE ALL INGREDIENTS IN A MIXING GLASS.
ADD LARGE ICE CUBES AND SHAKE VIGOROUSLY.
TASTE FOR BALANCE. DOUBLE-STRAIN
INTO A CHILLED COUPE, GARNISH, AND SERVE.

This recipe is not dissimilar to a classic pre-Prohibition cocktail called the Millionaire Cocktail.

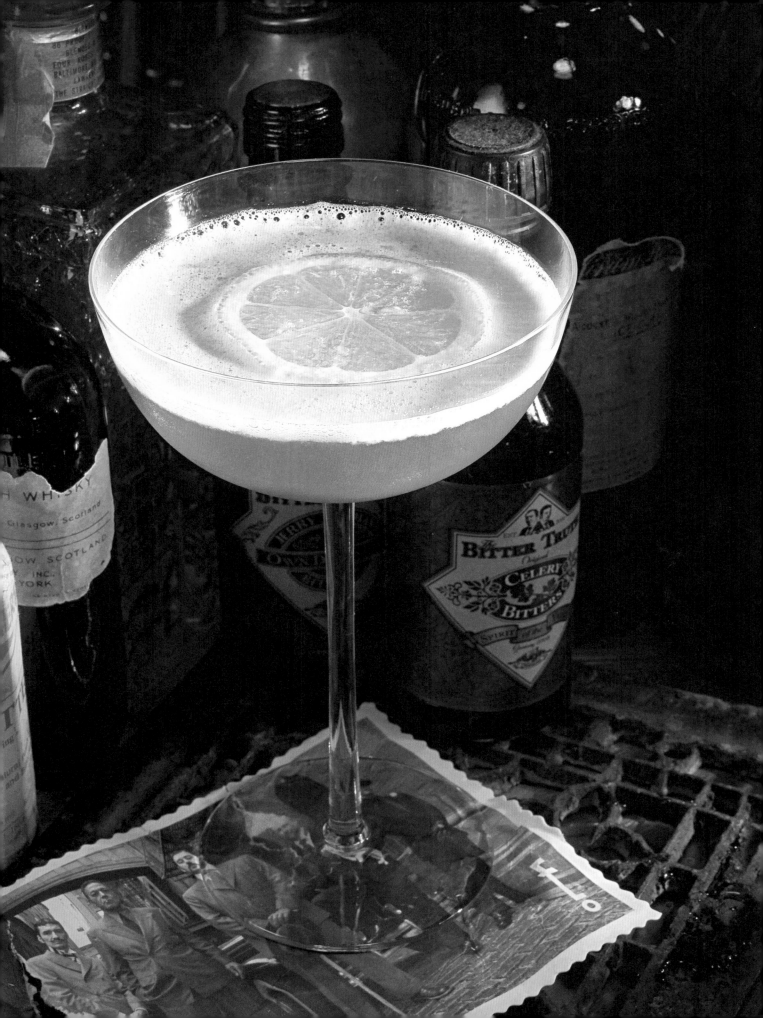

HOUSE CIDER RULES!

BASE SPIRIT: Reposado Tequila

1 3/4 oz. FRESH <u>NONALCOHOLIC</u>

APPLE CIDER

1/4 oz. FRESH

LEMON JUICE

1/2 oz. AGAVE NECTAR

1 1/2 oz. DON JULIO REPOSADO

TEQUILA

GARNISH:
CINNAMON
STICK

1/4 tsp. CINNAMON POWDER

PLACE ALL INGREDIENTS IN A COCKTAIL TIN AND DRY-SHAKE, TO EMULSIFY THE CINNAMON. ADD LARGE ICE CUBES AND SHAKE VIGOROUSLY.

TASTE FOR BALANCE. DOUBLE-STRAIN INTO A TUMBLER OVER FRESH ICE, GARNISH, AND SERVE.

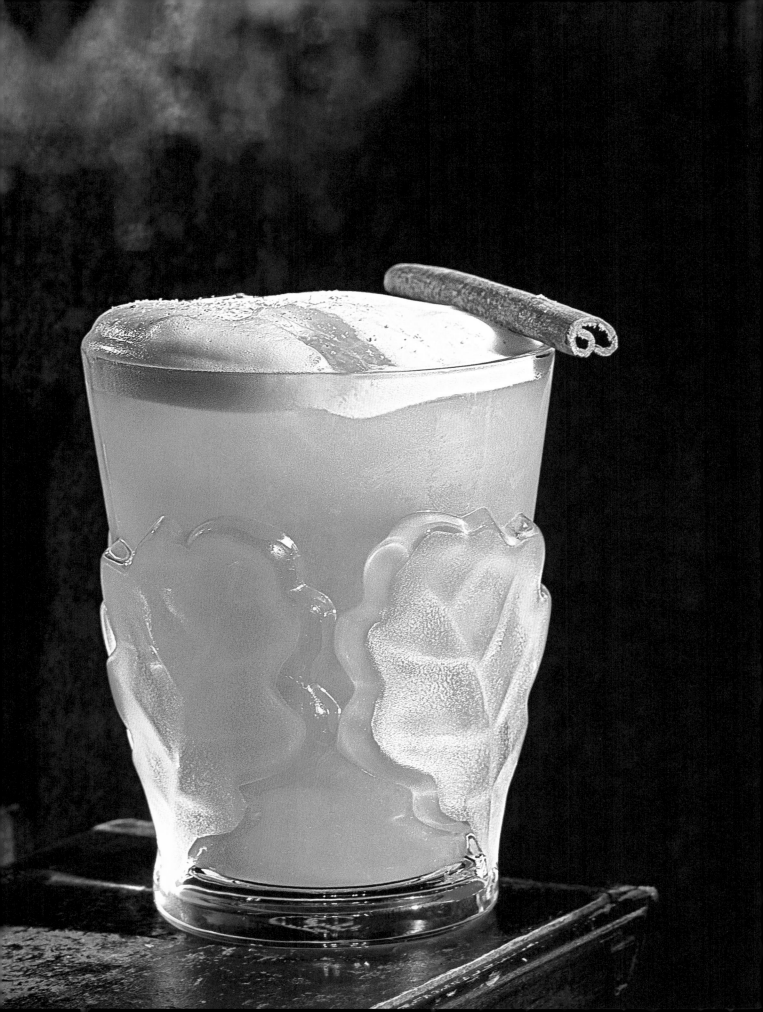

ODE TO EAU

BASE SPIRIT: Cointreau // MODIFIER: Plum Eau-de-Vie

1 1/2 oz. FRESH ORANGE JUICE

1/2 oz. FRESH LIME JUICE

1/4 oz. MASSENEZ MIRABELLE PLUM EAU-DE-VIE

1 1/4 oz. COINTREAU

2 DASHES FEE BROTHERS WEST INDIAN
ORANGE BITTERS

1/2 oz. GUS DRY VALENCIA ORANGE SODA

PLACE ALL INGREDIENTS EXCEPT SODA IN A MIXING GLASS. ADD LARGE ICE CUBES AND SHAKE VIGOROUSLY. ADD SODA AND TUMBLE ROLL BACK AND FORTH 1 TIME. TASTE FOR BALANCE. DOUBLE-STRAIN INTO A GLASS, GARNISH, AND SERVE.

GARNISH: APPLE OR PLUM DISC WITH A RASPBERRY & KUMQUAT AND/OR GRAPE SLIVERS

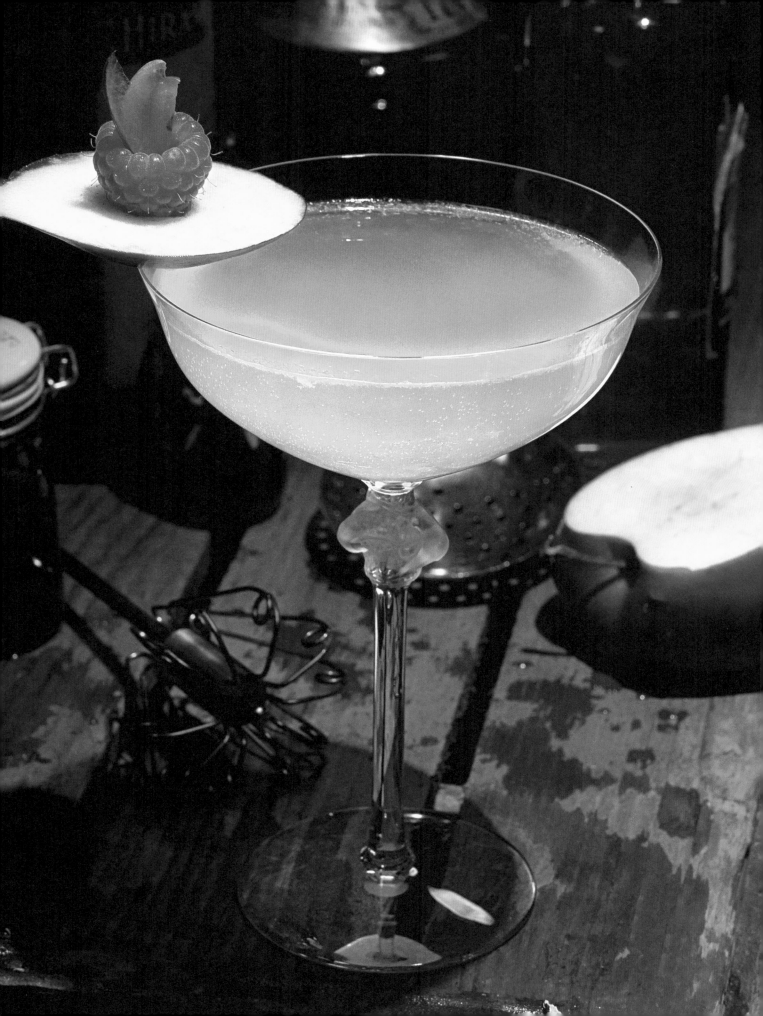

B.A.F.

BASE SPIRITS: Single-Malt Scotch & Oloroso Sherry // MODIFIERS: Gran Classico & Aperol

1/2 oz. APEROL

1/2 oz. GRAN CLASSICO BITTERS

1 oz. LUSTAU SOLERA RESERVA DRY OLOROSO "DON NUNO" SHERRY

1 oz. MACALLAN FINE OAK 10-YEAR SPEYSIDE SINGLE-MALT SCOTCH

GARNISH: LEMON TWIST

PLACE ALL INGREDIENTS IN A MIXING GLASS. ADD LARGE ICE CUBES AND STIR THOROUGHLY. TASTE FOR BALANCE. SINGLE-STRAIN INTO A GLASS OVER 1 EXTRA-LARGE CUBE. TWIST LEMON PEEL, DISCARD, AND SERVE.

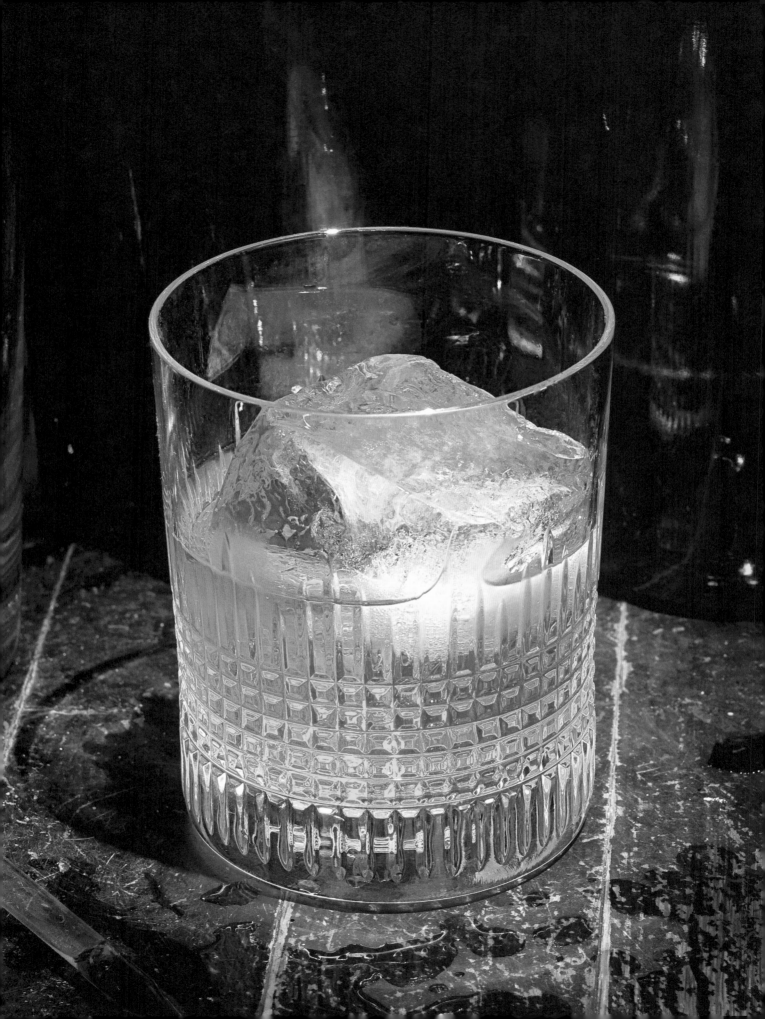

BROKEN HEART

BASE SPIRIT: Navy-Strength Gin // MODIFIER: Bénédictine

1/4 oz. ACACIA-HONEY SYRUP

1/4 oz. FRESH LEMON JUICE

2 oz. FRESH GRAPEFRUIT JUICE

1 LONG SLICE RED BELL PEPPER

1 SLICED RING JALAPEÑO PEPPER (SEEDS REMOVED)

1/2 oz. BÉNÉDICTINE

1 oz. PERRY'S TOT NAVY-STRENGTH GIN

PLACE NONALCOHOLIC INGREDIENTS IN A MIXING GLASS. MUDDLE PEPPERS. ADD BÉNÉDICTINE AND GIN. ADD LARGE ICE CUBES AND SHAKE VIGOROUSLY. **TASTE FOR BALANCE.** DOUBLE-STRAIN INTO A GLASS, GARNISH, AND SERVE.

GARNISH: RED-BELL-PEPPER HEART

BROKEN-HEART GARNISH:
From the same red pepper used for the cocktail, cut a two-by-two-inch square with a sharp paring knife. Lay the square out flat and carve out a heart shape. Cut a zigzag lightning bolt 2/3 of the way into the heart, and perch it on the glass. The garnish can be eaten.

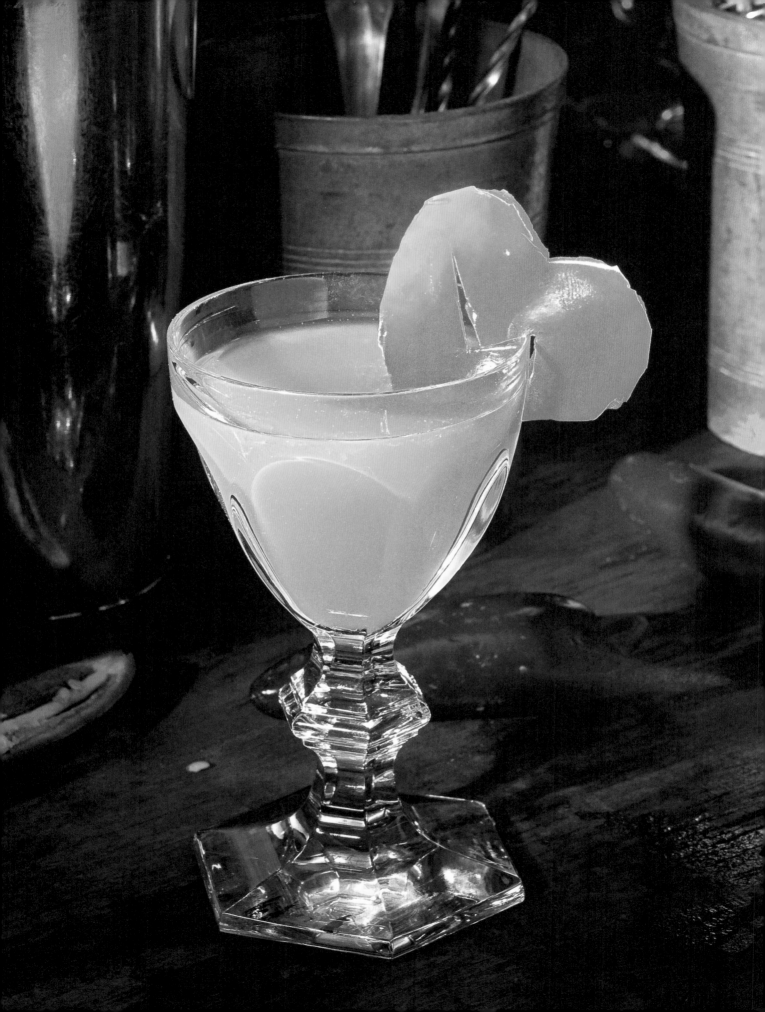

BLACKBERRY FOOL

BASE SPIRIT: Gin // MODIFIER: Crème de Mûre

3 MINT LEAVES
1 BLACKBERRY
1/2 oz. VANILLA SYRUP
1/2 oz. FRESH HEAVY CREAM
1/2 oz. FRESH LEMON JUICE
1/4 oz. CRÈME DE MÛRE
1 1/2 oz. DOROTHY PARKER AMERICAN GIN
3 DROPS ROSE WATER

MUDDLE MINT LEAVES AND BLACKBERRY WITH VANILLA SYRUP IN A MIXING GLASS. ADD LARGE ICE CUBES AND SHAKE VIGOROUSLY. TASTE FOR BALANCE. DOUBLE-STRAIN INTO A COUPE, GARNISH, AND SERVE.

GARNISH: MINT LEAF

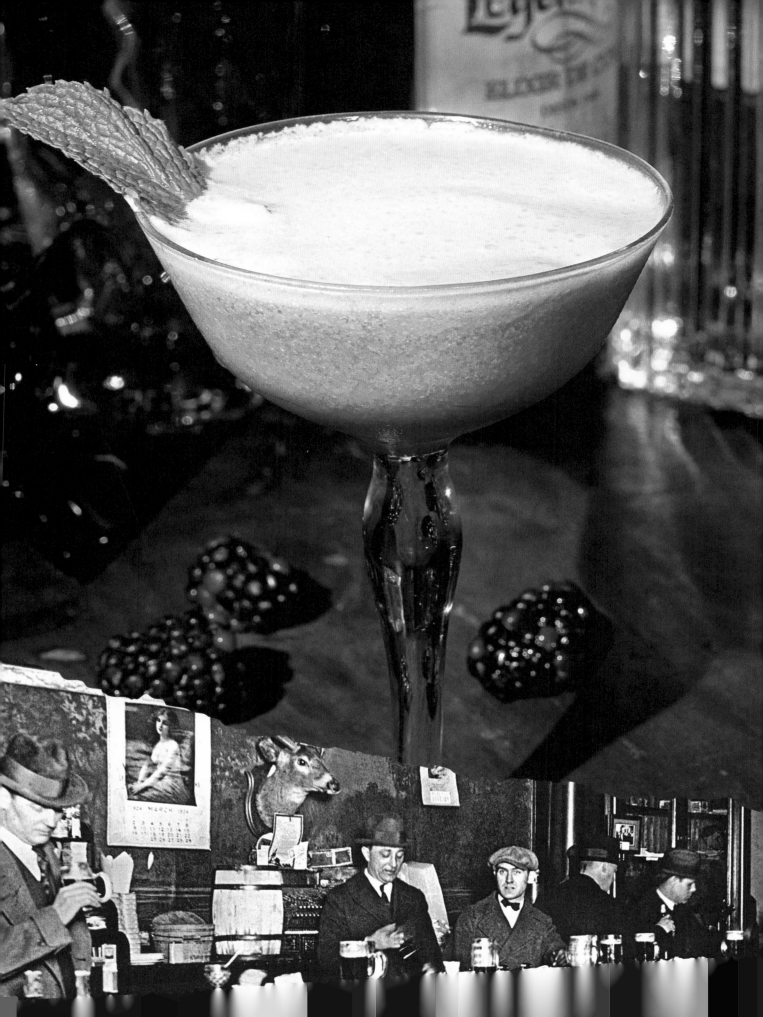

JACK AND SODA

BASE SPIRIT: Tennessee Whiskey // MODIFIER: Single-Malt Scotch

1/2 oz. CANE-SUGAR SIMPLE SYRUP

1/4 oz FRESH LEMON JUICE

1/4 oz. CONFECTIONARY VANILLA SYRUP

1/2 oz. CONFECTIONARY CARAMEL

1/4 oz AUCHENTOSHAN THREE WOOD SINGLE-MALT SCOTCH

1 1/4 oz. GENTLEMAN JACK TENNESSEE WHISKEY

1 oz. SPARKLING WATER

PLACE ALL INGREDIENTS EXCEPT SPARKLING WATER IN A MIXING GLASS. STIR AT ROOM TEMPERATURE UNTIL CARAMEL IS EMULSIFIED. ADD LARGE ICE CUBES AND SHAKE VIGOROUSLY. ADD SPARKLING WATER AND TUMBLE ROLL BACK AND FORTH 1 TIME. TASTE FOR BALANCE. DOUBLE-STRAIN INTO A HIGHBALL OVER FRESH ICE. GARNISH AND SERVE.

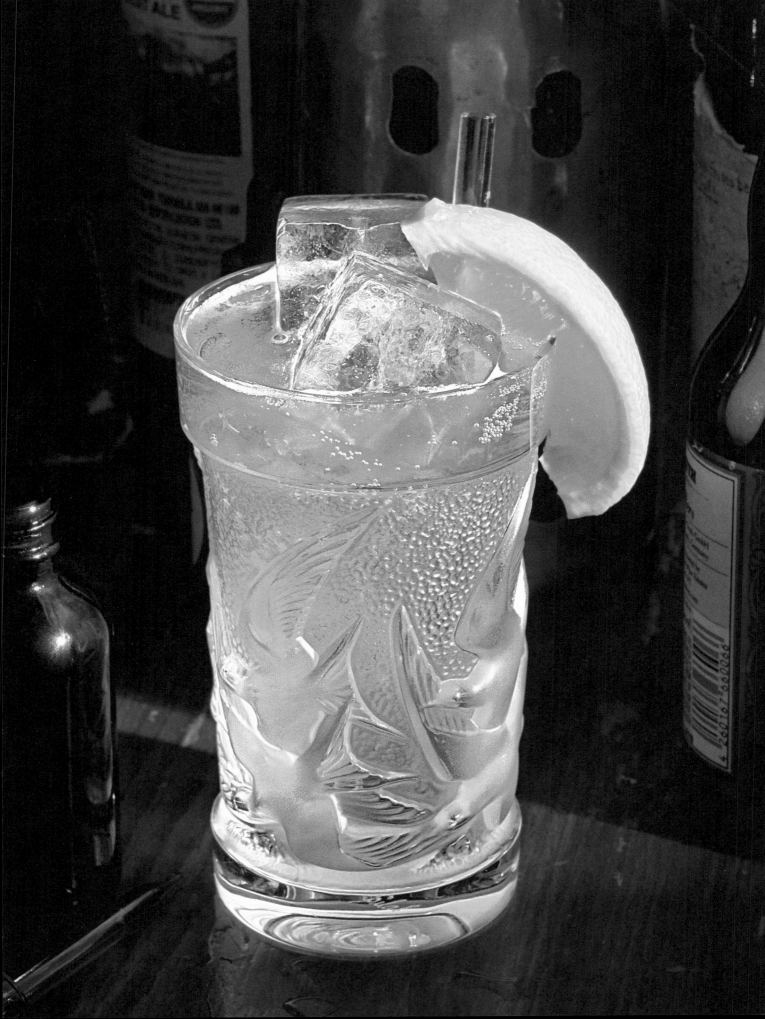

MAULED WINE

BASE SPIRIT: XO Cognac // MODIFIERS: Amaro & Amarone

1 SLICED ORANGE PEEL
1/2 CUP UNSWEETENED CRANBERRY JUICE
1 CUP HONEY SYRUP
1 tsp. FRESHLY GROUND CINNAMON
1/2 tsp. VITAMIN C CRYSTALS
1/2 tsp. FRESHLY GROUND CLOVE
1/2 tsp. FRESHLY GROUND ALLSPICE
2 tsp. FRESHLY SHAVED GINGER
1/2 CUP CAMUS XO ELEGANCE COGNAC
1/4 CUP AMARO MELETTI
1 750ml BOTTLE AMARONE

SERVES 4 to 6

PLACE NONALCOHOLIC INGREDIENTS IN A SAUCEPAN OVER MEDIUM HEAT. COOK UNTIL CONTENTS START TO BOIL. REMOVE FROM HEAT AND LET STAND FOR 1 MINUTE. ADD REMAINING INGREDIENTS AND STIR WITH WOODEN SPOON. TASTE FOR BALANCE. IF NOT HOT ENOUGH, BRING BACK TO A SIMMER OVER LOW HEAT. POUR FROM SAUCEPAN INTO A HEAT-RESISTANT GLASS OR CERAMIC PITCHER. SERVE HOT.

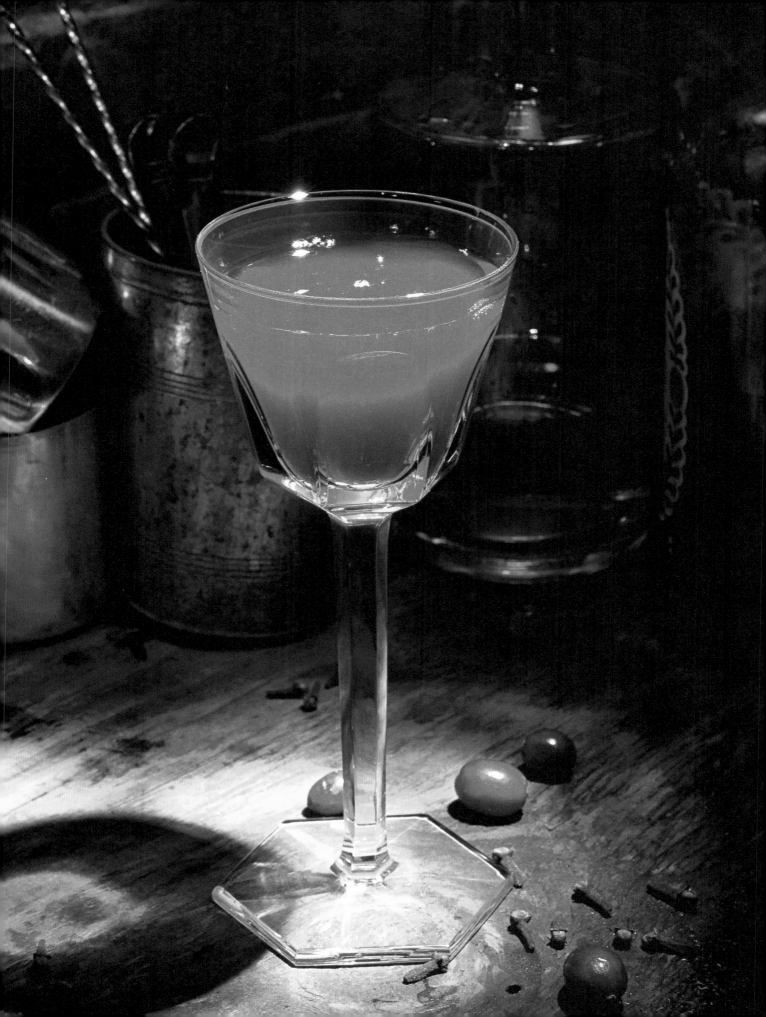

OATMEAL GINGER SHANDY GAFF

BASE SPIRIT: Barley Whiskey // MODIFIER: Oatmeal Stout

1/2 CLOVE
FRESH GINGER

1/2 OZ. CANE-SUGAR SIMPLE SYRUP

1/4 OZ. FRESH LEMON JUICE

1/2 OZ. STRANAHAN'S COLORADO BARLEY WHISKEY

12 OZ. SAMUEL SMITH'S OATMEAL STOUT

GARNISH: CANDIED GINGER

PEEL AND DICE GINGER, MUDDLE IN A CHINOIS WHILE POURING SIMPLE SYRUP OVER TOP TO EXTRACT JUICE. PLACE GINGER MIXTURE AND ALL OTHER INGREDIENTS INTO A CHALICE AND SLOWLY POUR BACK AND FORTH ONCE. TASTE FOR BALANCE. GARNISH AND SERVE.

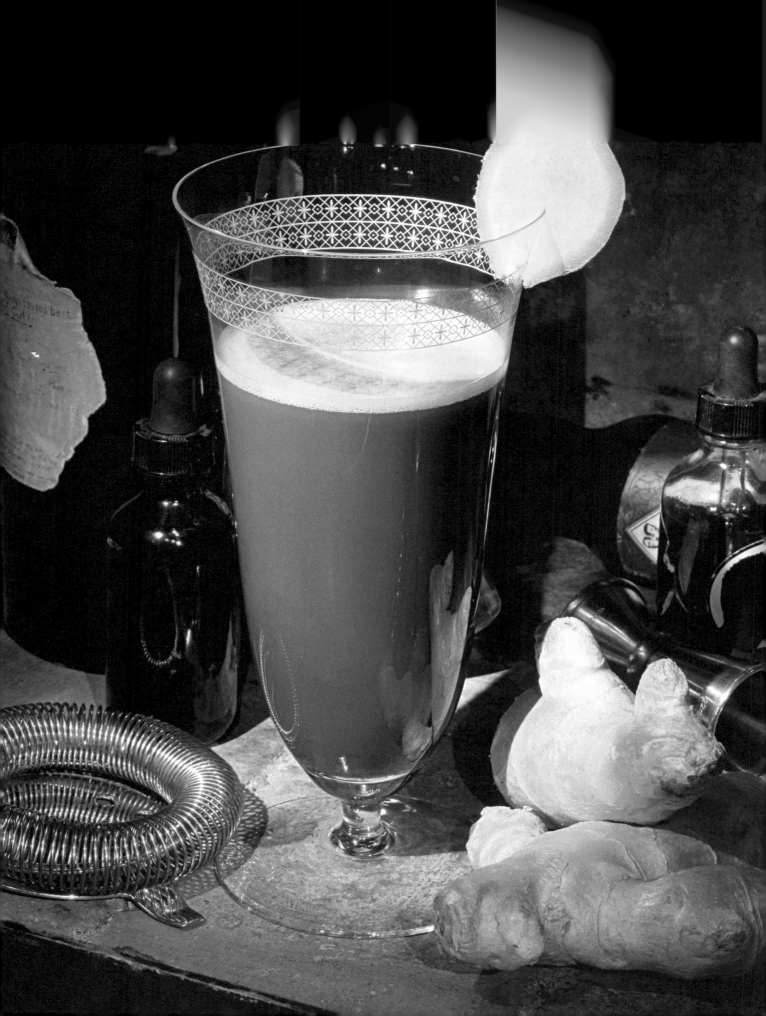

YELLOW JACKET

BASE SPIRIT: Tequila // MODIFIERS: Elderflower Liqueur & Yellow Chartreuse

2 oz. PARTIDA REPOSADO **TEQUILA**

1 oz. St. GERMAIN **ELDERFLOWER LIQUEUR**

3/4 oz. **YELLOW CHARTREUSE**

1 DASH REGAN'S **ORANGE bITTERS** No. 6

GARNISH:
LEMON TWIST

PLACE ALL INGREDIENTS IN A MIXING GLASS.
ADD LARGE ICE CUBES AND STIR THOROUGHLY.
TASTE FOR BALANCE. SLOWLY STRAIN
INTO A CHILLED COUPE, TAKING CARE
NOT TO AERATE. GARNISH AND SERVE.

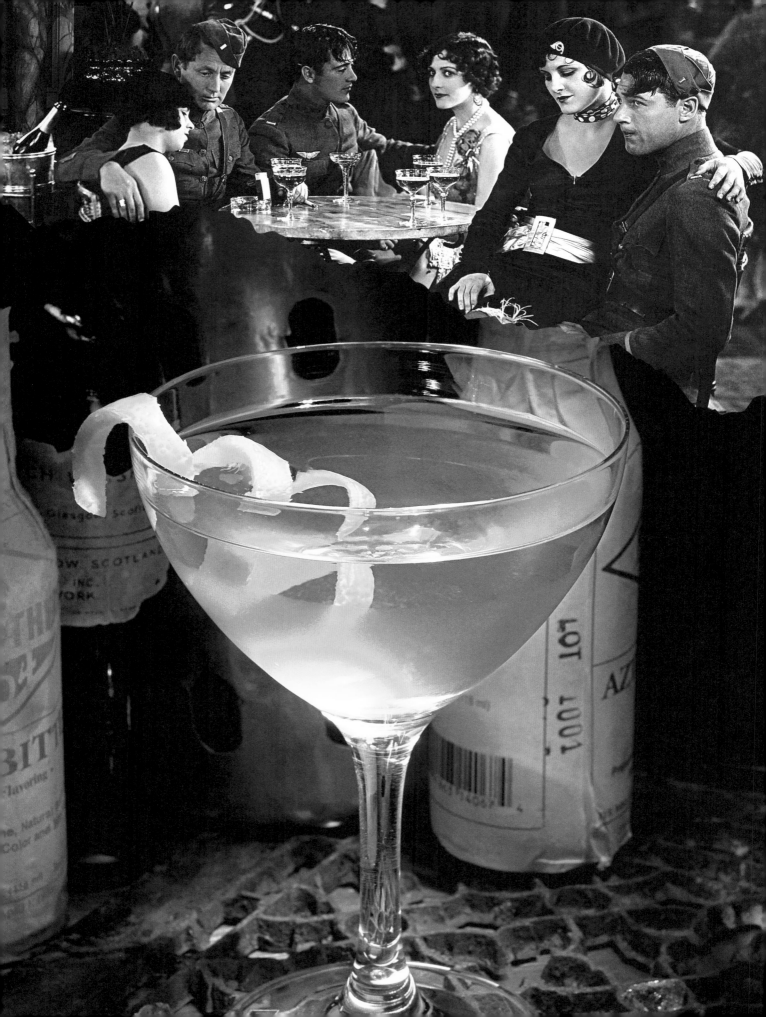

EDEN PARK

BASE SPIRIT: Gin // MODIFIERS: VEP Green Chartreuse & Absinthe Rinse

St. GEORGE
ABSINTHE RINSE

1 oz. DEMERARA-SUGAR SYRUP

1 oz. FRESH LEMON JUICE

1/2 oz. GREEN CHARTREUSE VEP

1 SPRIG FRESH TARRAGON

1 1/2 oz. TANQUERAY No. TEN GIN

GARNISH: 1 SPRIG FRESH TARRAGON

RINSE GLASS OUT WITH ABSINTHE. PLACE ALL INGREDIENTS EXCEPT
GIN IN A MIXING GLASS. MUDDLE TARRAGON, THEN ADD GIN
AND LARGE ICE CUBES AND SHAKE VIGOROUSLY.
TASTE FOR BALANCE. DOUBLE-STRAIN INTO THE GLASS,
GARNISH, AND SERVE.

134

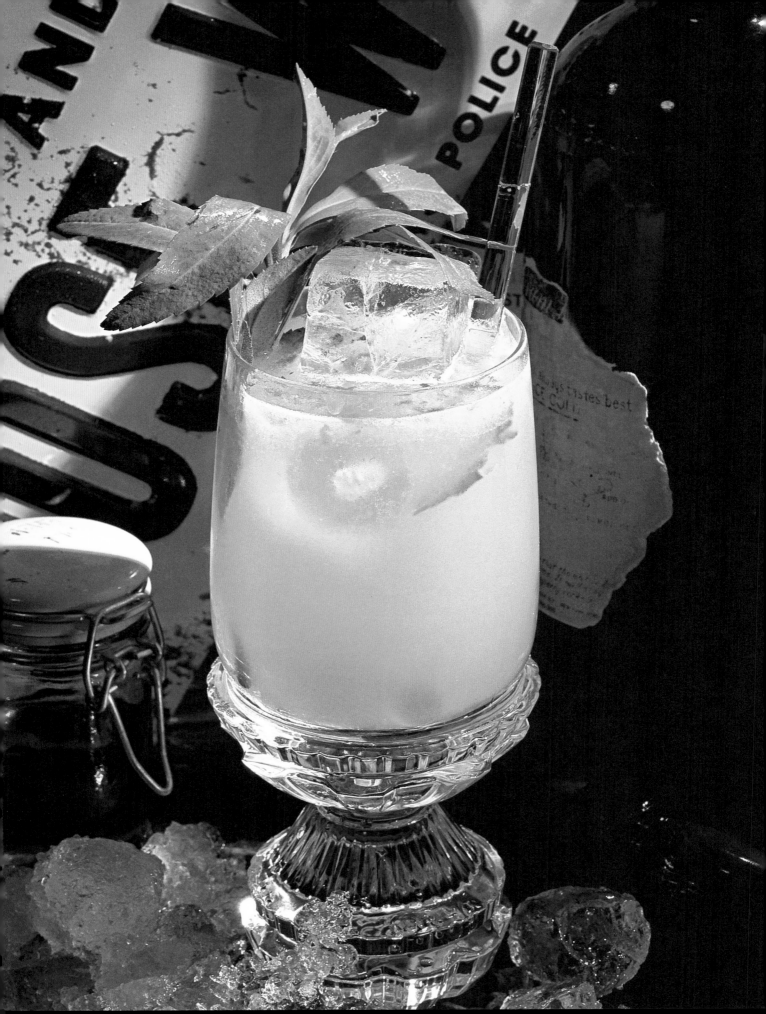

LA CHIC MARTINIQUE

BASE SPIRIT: Light Rhum // MODIFIER: Créole Shrubb

1/2 OZ. FRESH LIME JUICE

1 OZ. FRESH CLEMENTINE JUICE

3/4 OZ. DEMERARA-SUGAR SYRUP

1/4 OZ. JOHN D. TAYLOR'S VELVET FALERNUM LIQUEUR

GARNISH: KUMQUAT FLORET

1/2 OZ. CLÉMENT CRÉOLE SHRUBB

1 OZ. CLÉMENT V.S.O.P. RHUM VIEUX AGRICOLE

1 DASH DALE DEGROFF'S PIMENTO AROMATIC BITTERS

PLACE ALL INGREDIENTS IN A MIXING GLASS. ADD LARGE ICE CUBES AND SHAKE VIGOROUSLY. TASTE FOR BALANCE. DOUBLE-STRAIN INTO A GLASS, GARNISH, AND SERVE.

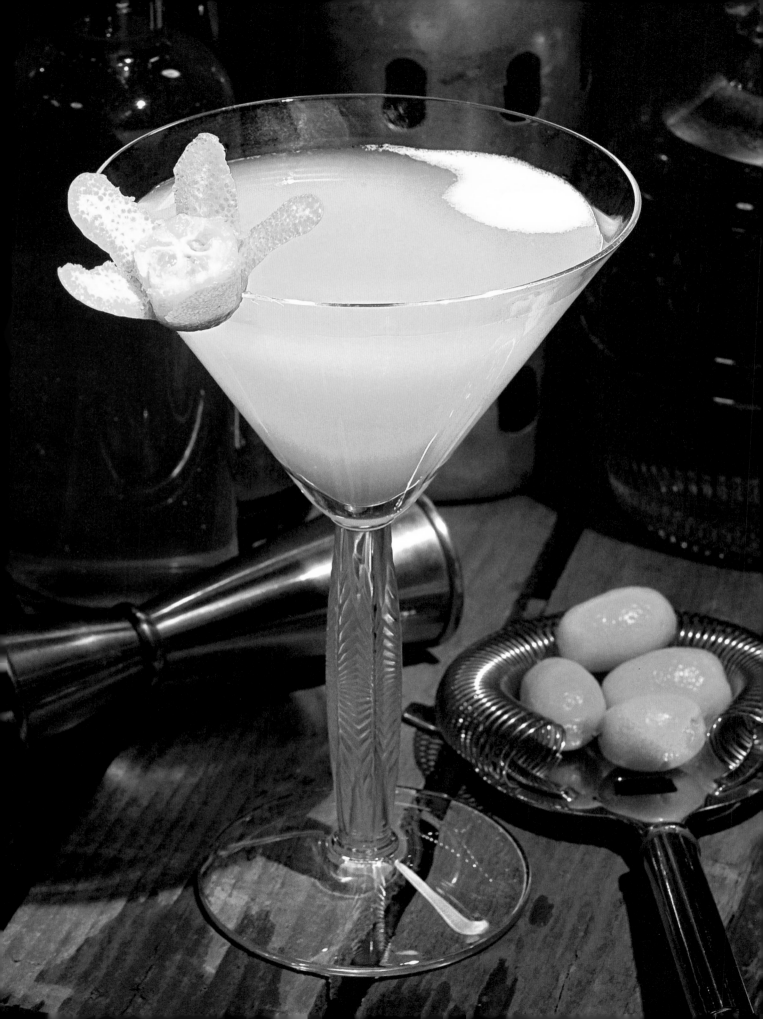

LARRY-JITO

BASE SPIRIT: Light Rum // MODIFIERS: Aged Rum, Red Burgundy, & Brachetto

3/4 OZ. CANE-SUGAR SIMPLE SYRUP

1/2 OZ. FRESH LIME JUICE

1 OZ. 10 CANE RUM

1/4 OZ. RHUM BARBANCOURT ESTATE RESERVE

5 MINT LEAVES

1 OZ DRY RED BURGUNDY

1/2 OZ. BANFI ROSA REGALE BRACHETTO D'ACQUI SPARKLING WINE

GARNISH: MINT SPRIG & LIME WEDGE

PLACE ALL INGREDIENTS EXCEPT WINES IN A MIXING GLASS; MUDDLE MINT. ADD LARGE ICE CUBES AND SHAKE VIGOROUSLY. ADD WINES AND TUMBLE ROLL BACK AND FORTH ONCE. TASTE FOR BALANCE. DOUBLE-STRAIN INTO A TUMBLER OVER FRESH ICE, GARNISH, AND SERVE.

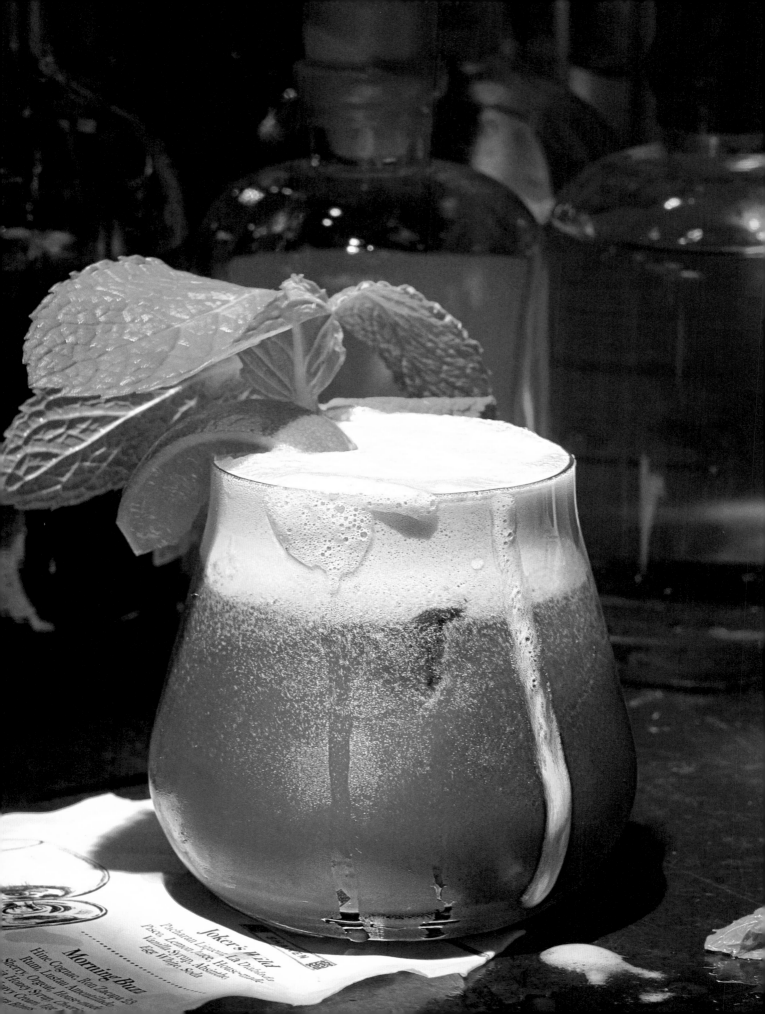

PROVENÇAL

BASE SPIRIT: Lavender-Infused Gin // MODIFIERS: Vermouth & Cointreau

3/4 oz. COINTREAU

1 1/4 oz. VERMOUTH DE PROVENCE (SEE BELOW)

2 oz. LAVENDER - INFUSED PLYMOUTH GIN (SEE BELOW)

GARNISH: ORANGE TWIST

PLACE ALL INGREDIENTS IN A MIXING GLASS. ADD LARGE ICE CUBES AND STIR THOROUGHLY. TASTE FOR BALANCE. SLOWLY STRAIN INTO A CHILLED COUPE, TAKING CARE NOT TO AERATE. GARNISH AND SERVE

VERMOUTH DE PROVENCE:
2 tbsp. herbs de Provence
1 750 ml. bottle Noilly Prat dry vermouth
Heat herbs in a saucepan over medium heat for 2 minutes, then add 2 cups of the vermouth. Bring to a boil and immediately remove from heat. Let cool, then add the remaining vermouth. Strain through a cheesecloth back into original bottle. Label and date.

LAVENDER-INFUSED GIN:
2 tsp. dried organic lavender 1 liter bottle Plymouth gin // Heat the lavender in a saucepan over low heat.
Add 2 cups of the gin and bring to a boil. Immediately remove from heat and let cool. Add the remaining gin.
Strain through a cheesecloth back into original bottle. Label and date. Do not store in sunlight.

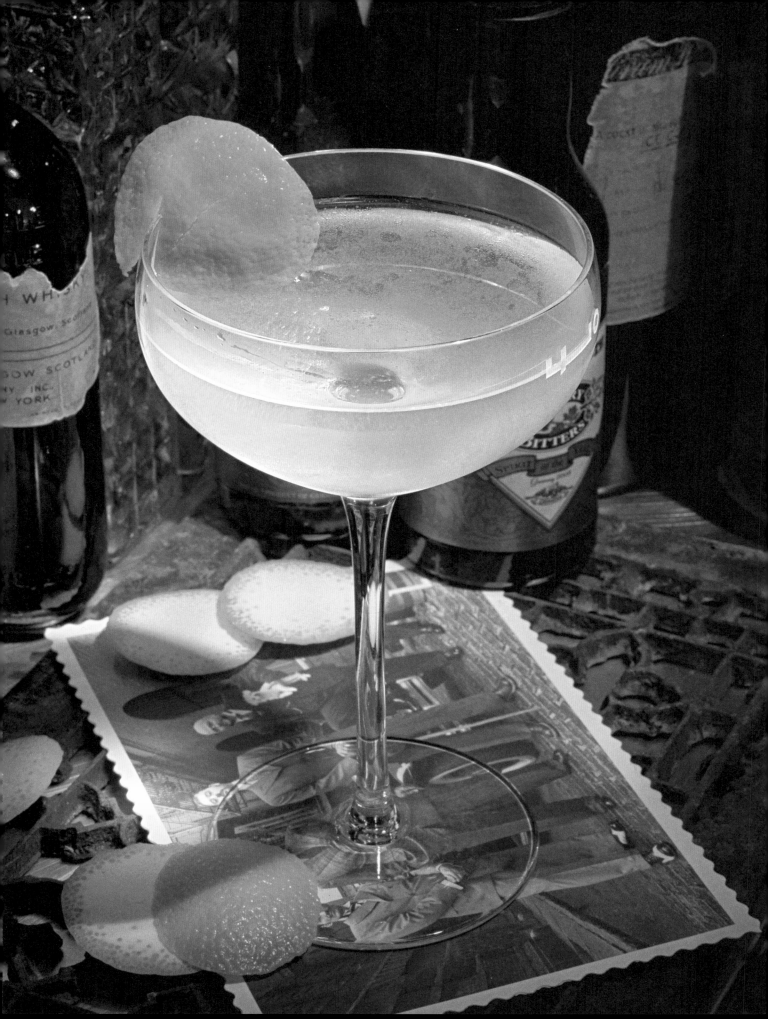

INDEX

METRIC CONVERSION CHART

¼ tsp = 1 ml	1 oz. = 30 g = 30 ml	32° F / 0° C
½ tsp = 2 ml	2 oz. = 60 g = 60 ml	250° F / 121° C
1 tsp = 5 ml	3 oz. = 90 g = 90 ml	300° F / 149° C
1 tbsp = 15 ml	4 oz. = 120 g = 120 ml	450° F / 233° C
¼ cup = 50 ml	8 oz. = 240 g = 240 ml	
1/3 cup = 75 ml	16 oz. = 480 g = 480 ml	
½ cup = 75 ml		
2/3 cup = 150 ml		
¾ cup = 175 ml		oz. = ounce
1 cup = 250 ml		tsp = teaspoon
1 quart = 1 liter		tbsp = tablespoon

ACKNOWLEDGMENTS

The author would like to thank the following individuals, establishments, and companies for their contributions to this book:

Bridget Albert; Sven Almenning; Angostura Inc.; Prosper and Martine Assouline; Astor Center; Bacardi; Baccarat; Bar Rescue; Mario Batali; Beam Global; Jeff Bell; Jacques Bezuidenhout; Bols; the Boys at E.O.; Frank Bruni; Chandler Burr; Bushwick Country Club; Salvatore Calabrese; The Carlyle; Ludovic Chevrot; Clover Club; Rémy Cointreau; Tom Colicchio; Ron Cooper; Daniel Craig; The Crown; C. Wonder; Alexander Day; Death & Co.; Bob Deck; Enrique de Colsa; John DeBary; Dale and Jill DeGroff; Diego de Mola; Diageo; Simon Difford; Dolce & Gabbana; Peter Dorelli; Camille Dubois; Elyane Duke-Duff; Philip Duff; Employees Only; Encantado Resort; Esca; Don Julio González-Frausto Estrada; Brad Farran; Fee Brothers ; Julie Foo-Chee; *Food Arts* magazine; Food Network; Kyle Ford; Rachel Ford; Simon Ford; Brown Forman; Four Seasons Costa Rica; Eben Freeman; The French Laundry; Doug Frost; Tony Abou-Ganim; Ina Garten; Billy Gilroy; Gramercy Tavern; Grand Hyatt NYC; Gael Greene; Alain Gruber; Anastasia Gura; GuS; Igor Habzismajlovic; John Hardison; Kimberly Hicks; Steve and Jeanette Hirsh; Igby's; James Beard Foundation; Dev Johnson. Benjamin Jones; Dave Kaplan; Marko Karakasevic; Jason Kosmas; Allen Katz; Thomas Keller; Kold-Draft; Esther Kremer; Henry LaFargue; Francesco LaFranconi; Lalique; Victorine Lamothe; Liveo Laureo; Don Lee; Eric Lilavois; Tom Macy; Mandarin Oriental Hong Kong; Mansion on Turtle Creek; James McBride; McIlhenny Co.; Dave McNulty; Jim Meehan; James Menite; Junior and Heidi Merino; Brian Miller; Michael Minnillo; Jeffrey Morganthaler; Larry Nadeau; New York Distilling Company; Steve Olsen; Paul Pacult; David Pasternack; PDT; Per Se; Jean-Luc Picard; Porter House New York; Redeye Grill; Eryn Reece; Gary Regan; Julie Reiner; Paul Roberts; Frankie Rodriguez; Rosenthal; Sebastian Rouxel; Russian Cocktail Club; Lynne Ryan; Captain Dag Saevik; Audrey Saunders; Arjan Scheepers; Eric Segalbaum; Andy Seymour; Willy Shine; David Slape; Southern Wine & Spirits; Alex Tabb; Jon and Nicole Taffer; Tales of the Cocktail; Professor Jerry Thomas; Tiffany & Co; Hidetsugu Ueno; United States Bartenders Guild; Kevin and Jennifer Van Flandern; Michael and Melissa Van Flandern; Phil Sher and Connie Van Flandern; Tom and Barbara Van Flandern; Grisel Vargas; Versace; Jessica Viana; Charlotte Voisey; Jillian Vose; Phil Ward; Whole Foods; Williams Grant; Wines from Spain; Dave and Karen Wondrich; *The World* ship; Naren Young; and Dushan Zaric.